# SPIRIT OF THE WILD

## STEVE BLOOM

Thames & Hudson

**For Dan and Adam**

ACKNOWLEDGMENTS

The authors of quotations as credited.
Kathy Bloom, Jan and Chris Bridge, Phil Jones, Susan Maxwell,
Stine Norden, Connie Robertson, Søren Rud and Lin Wilkinson.
The Worldwide Fund for Nature — www.wwf.org

First published in 2007 in hardcover in the United States of America by Thames & Hudson Inc.,
500 Fifth Avenue, New York, New York 10110

thamesandhudsonusa.com

Library of Congress Catalog Card Number 2006904270

ISBN-13:   978-0-500-51320-0
ISBN-10:   0-500-51320-1

Printed and bound in Singapore by CS Graphics

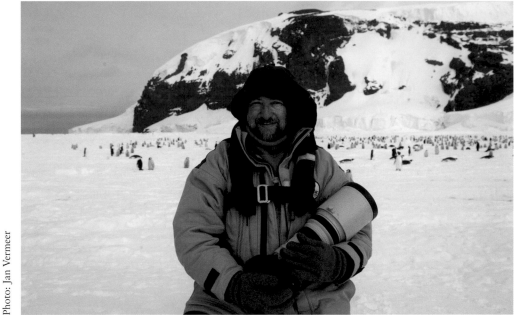

# STEVE BLOOM

STEVE BLOOM creates evocative photographic images of the living world. Born in South Africa, he moved to England in 1977 and worked in the graphic arts industry before swapping his established career for the precarious life of a travelling photographer. He has won awards for his innovative work, which is widely published throughout the world. His public exhibitions in city centres have been seen by millions.

Concern for the environment is strongly evident in all of Steve Bloom's images. He strives to capture the very spirit of the animals included in this book, and to blur the lines separating different species, creating an intuitive sense of kinship with other forms of life. At a time when so many animals are endangered and habitats are vanishing, he has journeyed to some of the most remote regions of the Earth in his quest to capture images that serve to remind us of the beauty in the world, and our duty to respect, protect and preserve it.

# PHOTOGRAPHY

*is the embodiment of nature's choreography:
a perpetual dance for the eye*

There is something about the directness of photographs that I find so stimulating. They are tiny slices of frozen time: moments captured and shared. For those who create photographs, the camera can become an extension of the heart: a paintbrush, a musical instrument, a notebook of memories.

I began photographing animals quite incidentally, at the age of forty. Like so many other city dwellers, I went on a safari holiday and took a camera with me. It was quite innocuous really, and I had no idea where it would lead. Those first images were somewhat mediocre, but when I looked at them closely, it dawned on me that many of us live in a world quite separated from nature; yet paradoxically, we are part of nature. Our metropolitan lives are often immersed in technology, trivial gossip and political scandals. Sometimes it's hard to see beyond where the pavement stops, and we can delude ourselves by believing that the wider world is something separate or impervious to our actions. In our selfishness, we can cause unlimited destruction in order to maintain lifestyles and values which may be mainly artificial. An arrogant attitude of superiority is not the most skilful way for humans to progress. All forms of life are connected, and there is much we can learn from the world's wildlife.

On this premise, my journey began. Initially I set off in search of the three great apes in the wild: orang-utans, chimpanzees and gorillas, and I produced a book about them and other primates. For years I travelled the world. At first I was complacent, but then I discovered

the alarming rate at which environmental destruction is accelerating, and was overcome by a sense of urgency and foreboding. My goal ever since has been to search for something of the spirit of the world's wildlife: the tiger's eyes in the jungles of India, polar bear cubs seeing the world for the first time, the few remaining mountain gorillas in Africa. Occasionally I have taken pictures in breeding centres or sanctuaries, though the creative objective remains paramount. My photographic approach has always been intentionally artistic, rather than scientific, as I believe that the eye and the camera can speak their own alternative languages. The photographer in the role of artist aims to draw viewers into the pictures, so creating a wider intuitive awareness of the world around us.

It is humbling to witness the diversity of life in so many places, and to have the opportunity to share such experiences with others. The international publication of the large coffee-table volume, *Untamed*, along with public exhibitions in city centres, have brought the work of many years to the eyes of people worldwide. Work, much like life, generally remains unfinished, and so the pictures I have produced are merely a microcosm of the world, like a few grains of sand on an endless beach: grains which change with time as the cycle of life continues.

Steve Bloom

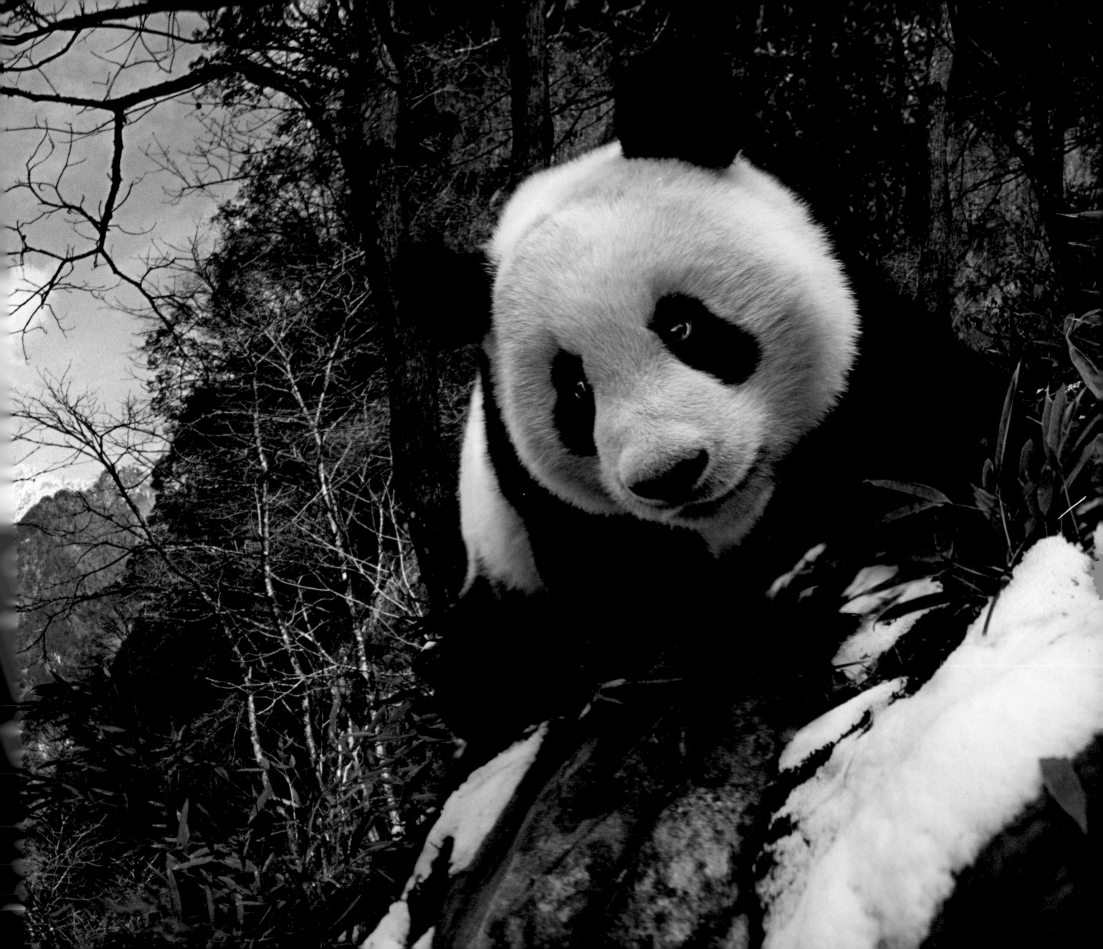

# SENTIENCE

I have seen a zoo elephant who appeared to have lost his spirit: a deeply disturbed psychotic shell, swaying back and forth repetitively on the same small patch of cracked concrete. He emitted no sound, but surely screamed from within. I have heard stories about dolphins crying when butchered by fishermen. And I have seen white tears stream down the face of a young hippo while he was being attacked by lions who were not hungry; so proving that animals do weep, and that we alone cannot claim to have the monopoly on senseless violence. Thankfully, I have also seen spinner dolphins follow my boat in the Atlantic, coming and going, leaping out of the water with apparent joy. I have watched elephants bathe in mud, their happiness clearly expressed. When a mother wildebeest sees her baby for the first time, there is something in the exchange that we can all recognize. Young springbok leap into the air in a way which most people identify as nothing less than the expression of pleasure. I defy anyone who has heard the song of whales to remain unaffected by the experience. The spirit of the wild is the spark of life, the very mystery that gives animation and unpredictable direction to all those with a heartbeat. Acknowledging the spirit in others is the recognition of sentience: the capacity for feeling and the experience of conscious awareness. It is very easy to be dismissive of animals simply because they are physically different, or speak a different language. Elephants, for example, speak their own language, by emitting low frequency sounds. They are able to communicate with each other over vast distances. Anyone who has spent time watching elephants

cannot help but acknowledge the presence of characteristics so like yours and mine.

The question of whether animals should be granted the same basic legal and moral rights as humans often provokes heated discussion, with great polarity of thought as people wrestle with the difficulty of resolving such issues. In situations of war, the ability of people on opposite sides to feel empathy for each other is overpowered by rage, detachment and a deep sense of injustice. With no apparent common interests at heart, appalling violence takes place without too much soul-searching. It is

little wonder then, that animals, who look and act so differently from humans, are seldom perceived as sharing many of our human traits.

If, however, great apes act with conscious intent and have a sense of self, then such cognitive faculties make them eligible for many of our basic rights. The question then arises as to which other animals possess this eligibility, and why our own self-appointed criteria should be the only valid ones for making important judgements about other lives. At which point do we make a distinction in order to determine when they become ineligible for such rights? Most people with dogs and cats recognize sentience

## The Indian Elephant is said sometimes to weep

CHARLES DARWIN

in the animals with whom they have relationships. The rest is a question of degree. It becomes harder to maltreat an animal to whom we have given a special name.

The growing evidence that animals possess high levels of cognitive faculties continues to further erode the historical view that they are machine-like, without conscious thought. While it is clear that contemporary human cultures involve rapid changes in innovation and transformation, forms of culture also exist in the animal world, albeit at a much slower rate of change. Culture, seen as the process of learning and practising the habits of others in a group, is clearly evident in macaques who have learned to wash sweet potatoes, and have subsequently imparted that knowledge to future generations.

On a more simplistic level – and this is where my role as photographer comes in – it is just a question of seeing and believing. In my animal photography, I bypass 'philosophical' arguments, and choose instead to approach subjects from a personal viewpoint. My images are not about reason or scientific conclusion, but are an aesthetic reaction to the common bonds which I, as a human being, have come to recognize, explore and then accept through the medium of photography.

We do, after all, breathe the same air and share the same planet, and we're all made of atoms. We are equally dependent on the sustainability of the Earth's natural resources. And when I look at the hand of a chimpanzee, I see a hand not dissimilar from my own.

In the mountains of Japan one winter morning, I recall watching a snow monkey examining her own arm. I felt drawn into her contemplation as she focused on her long, elegant fingers and perfectly formed nails: details, so like yours and mine. It is the recognition of such details that helps to bind us together, and acts as a reminder to acknowledge all that we share. History is littered with miscarriages of justice: executions of the innocent, untold suffering at the hands of those who believe they are justified in order to uphold a greater good. No traumatized child cares whether the trauma being suffered is for the benefit of one cause or another. Likewise, in our treatment of animals, we may argue that they do not suffer as we do, that they are of a lower order and therefore their welfare is unimportant.

But assume we are wrong, and what if animals exist on a higher cognitive level than we realize? Surely, as the most dominant species, it is better to take the highest ethical stance and treat them with conscious respect, on the assumption that they share levels of sentience with us? If we acknowledge the dignity of animals and treat them accordingly, we will become more compassionate in our dealings with the world in general and will surely feel better about ourselves.

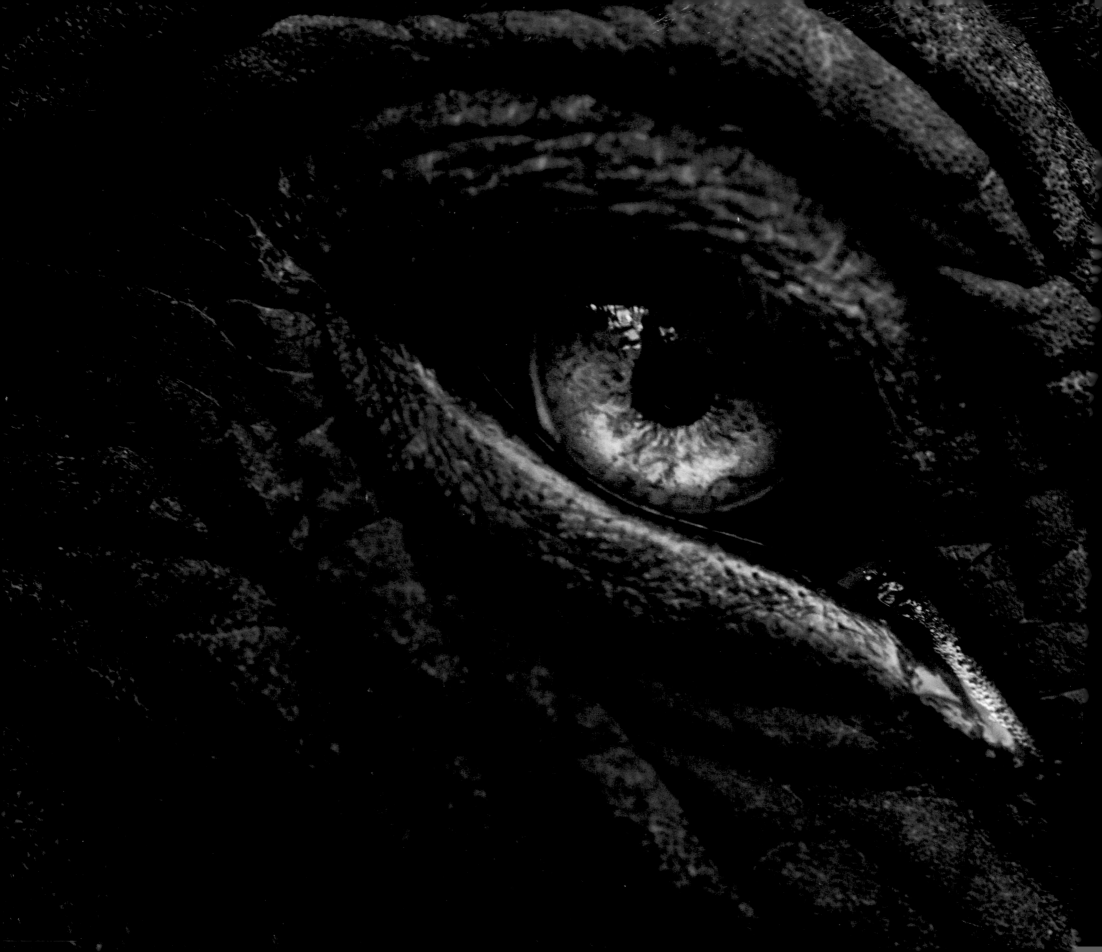

*If you have men who will exclude any of God's creatures
from the shelter of compassion and pity, you will have men who
will deal likewise with their fellow men.*

ST FRANCIS OF ASSISI

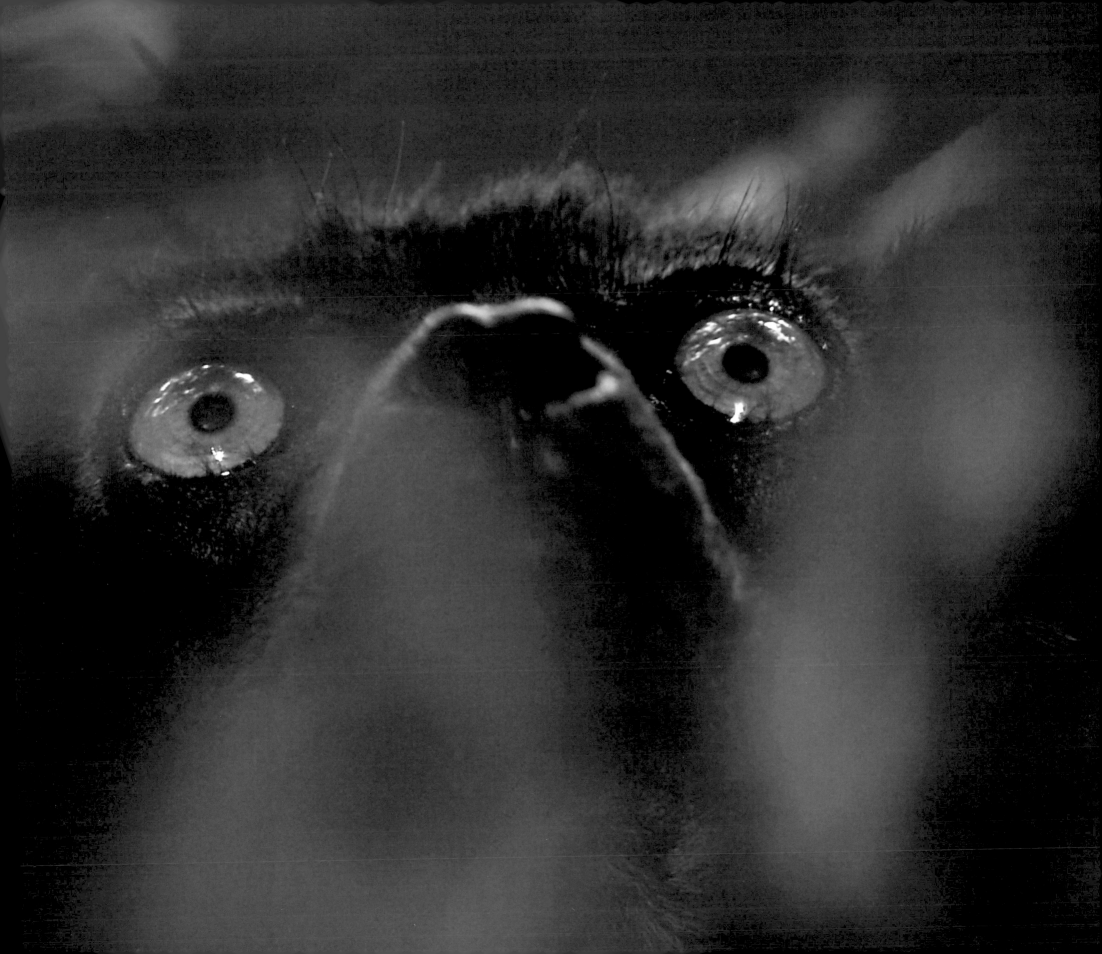

*Deliberate cruelty to our defenceless
and beautiful little cousins is surely
one of the meanest and most detestable vices
of which a human being can be guilty.*

WILLIAM RALPH INGE

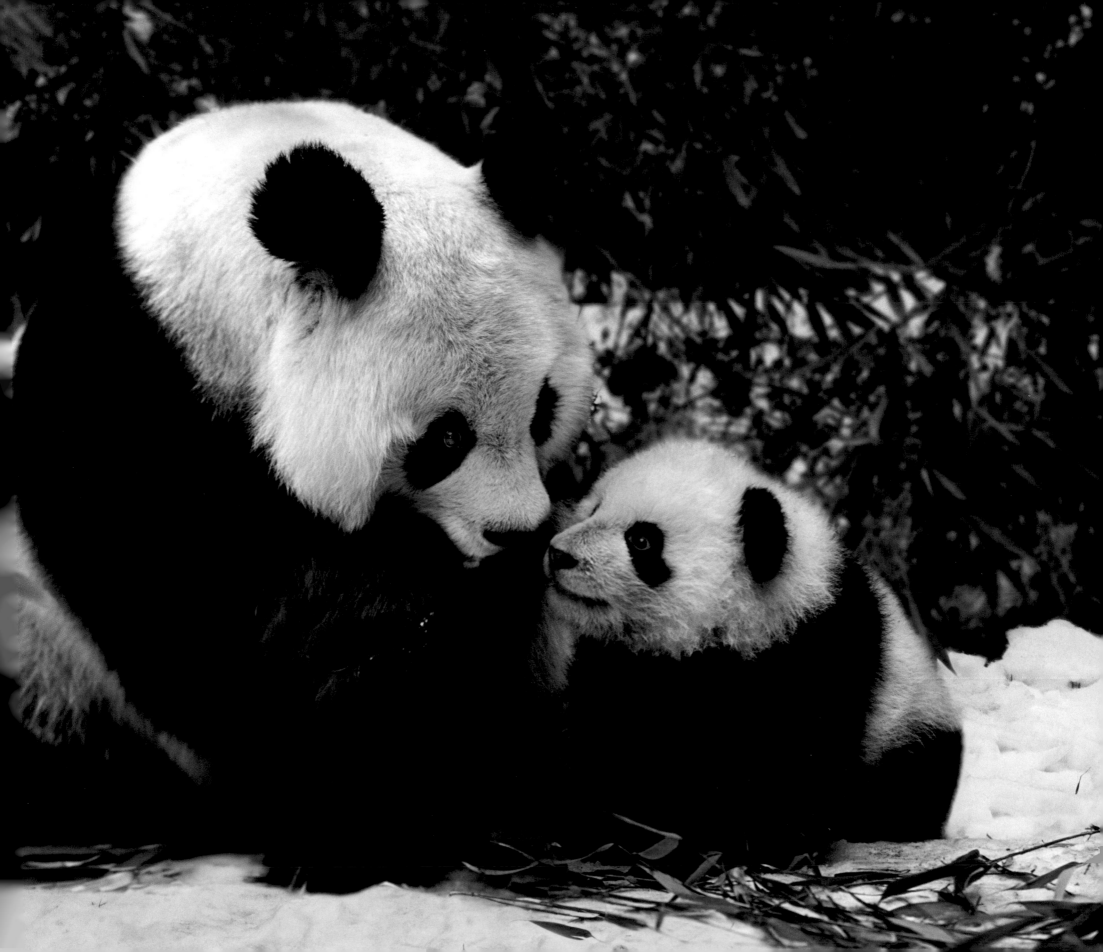

*If all the beasts were gone, men would die*
*from a great loneliness of spirit,*
*for whatever happens to the beasts also happens to the man.*
*All things are connected.*

CHIEF SEATTLE OF THE SUWAMISH TRIBE

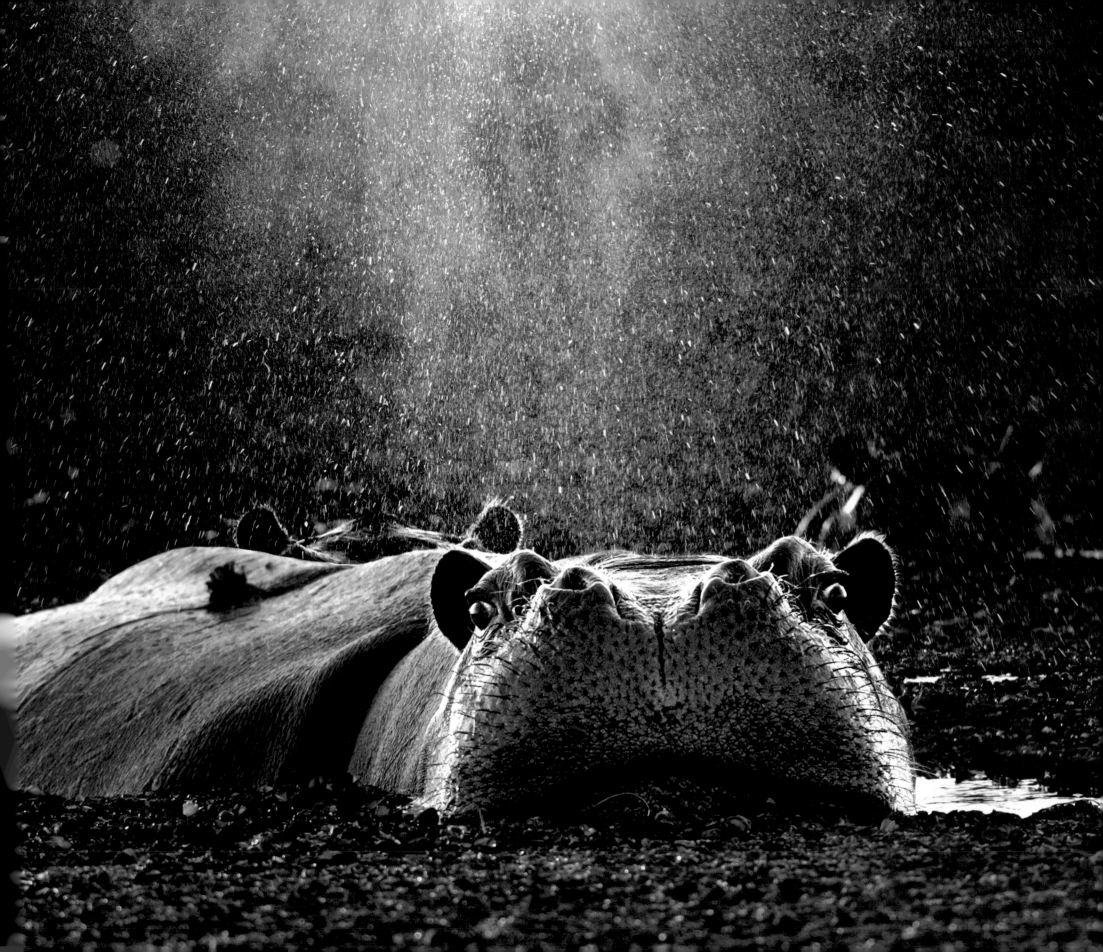

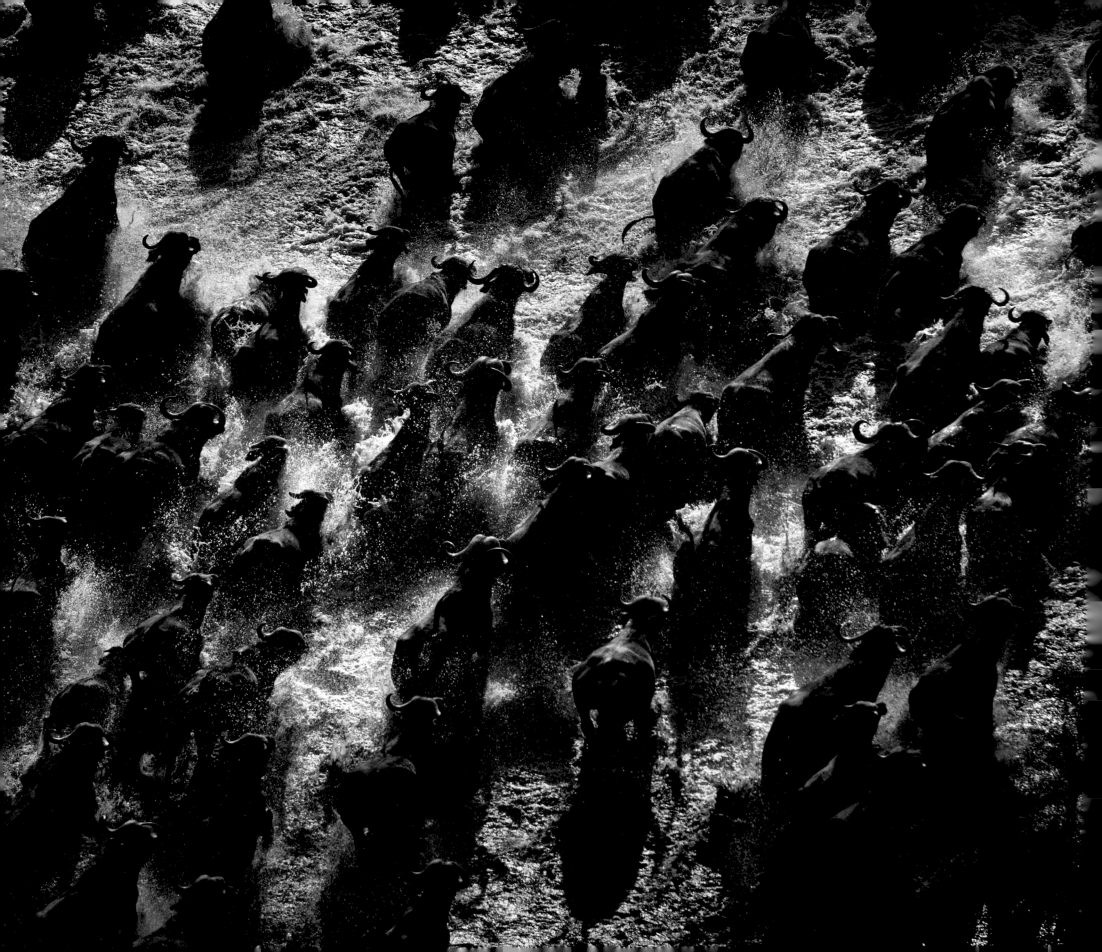

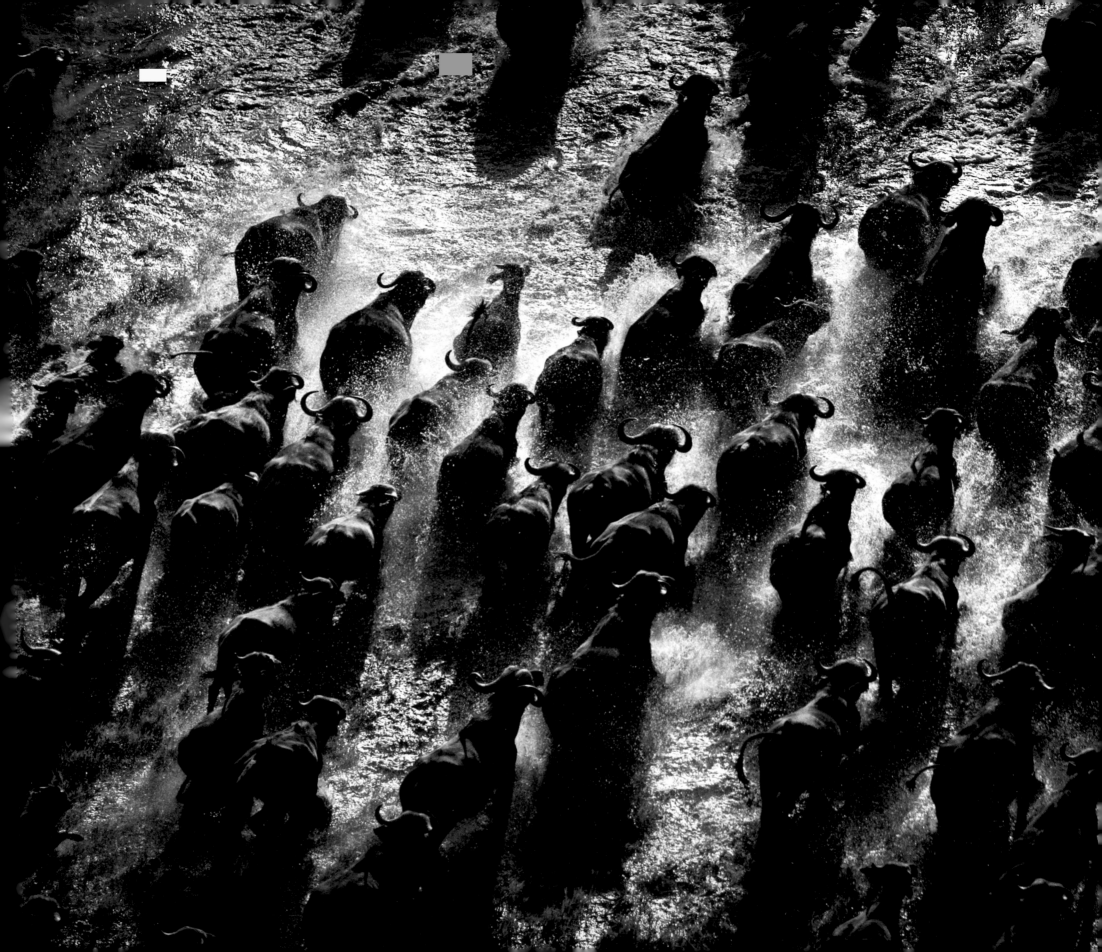

*The greatness of a nation and its moral progress can be judged
by the way its animals are treated.*

MAHATMA GANDHI

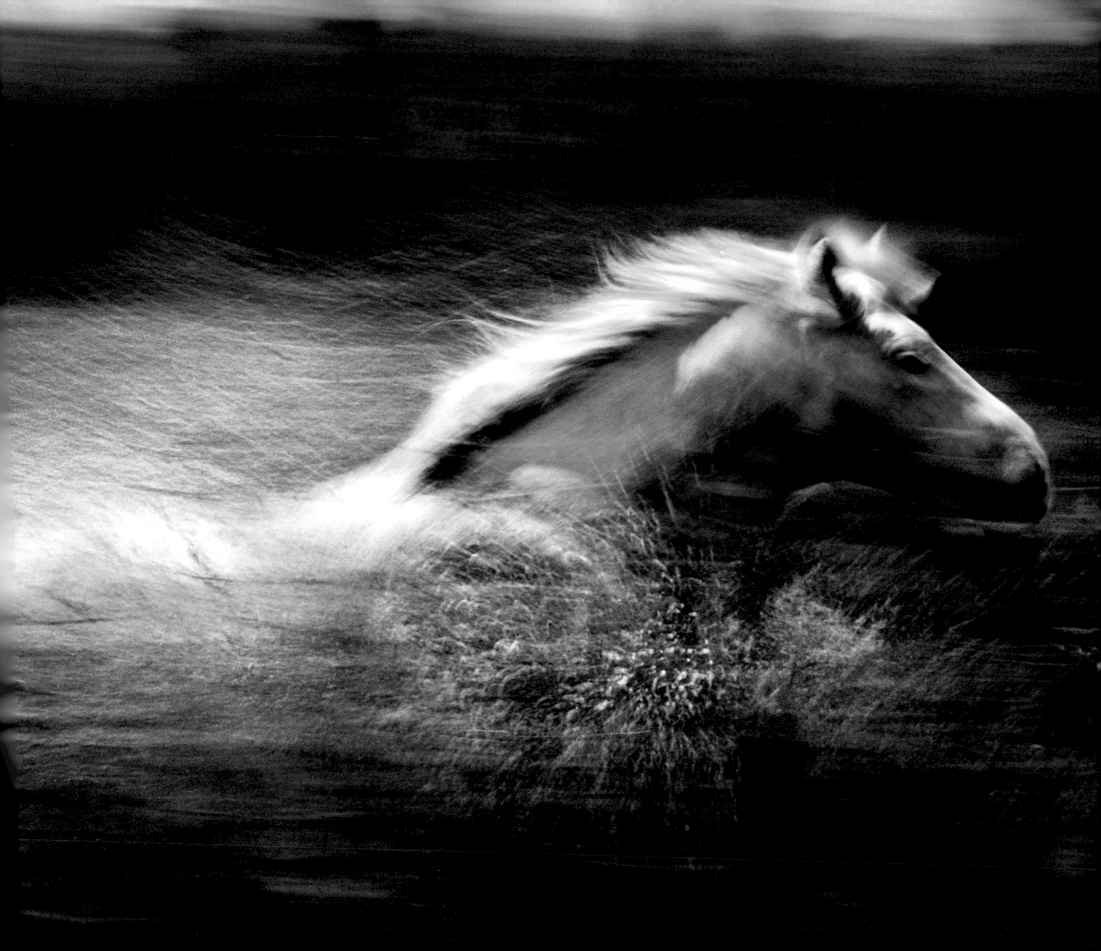

A robin red breast in a cage
Puts all Heaven in a rage.

WILLIAM BLAKE

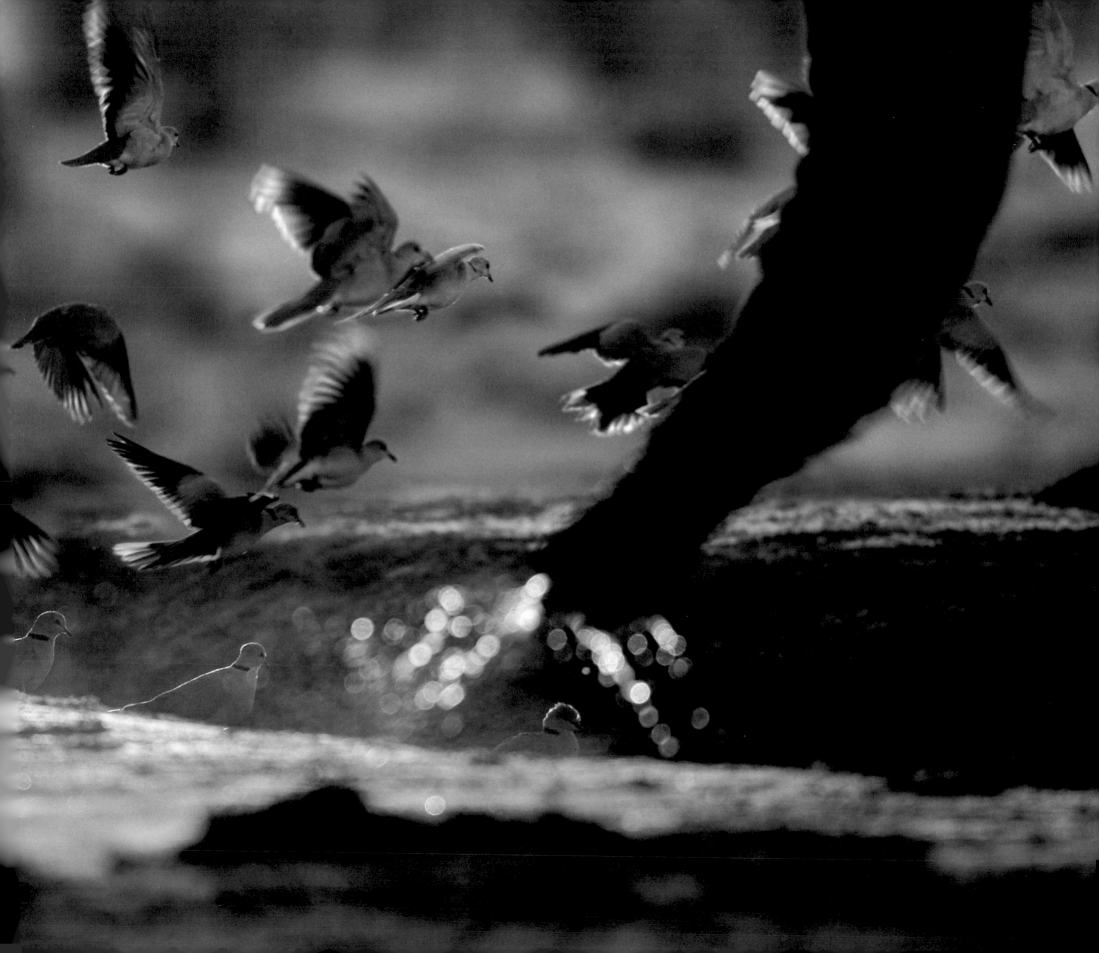

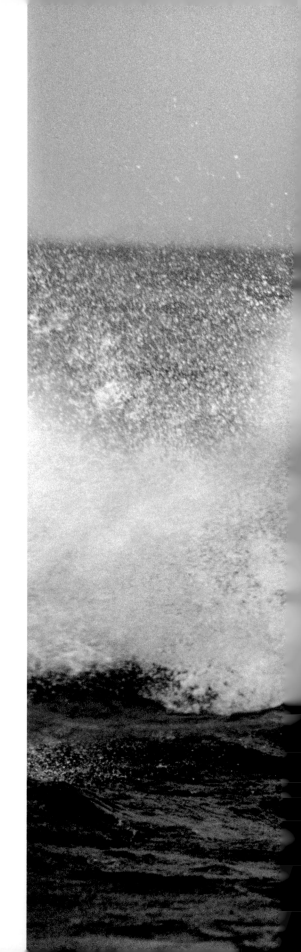

There is, one knows not what sweet mystery about this sea,
whose gently awful stirrings seem to speak
of some hidden soul beneath.

HERMAN MELVILLE

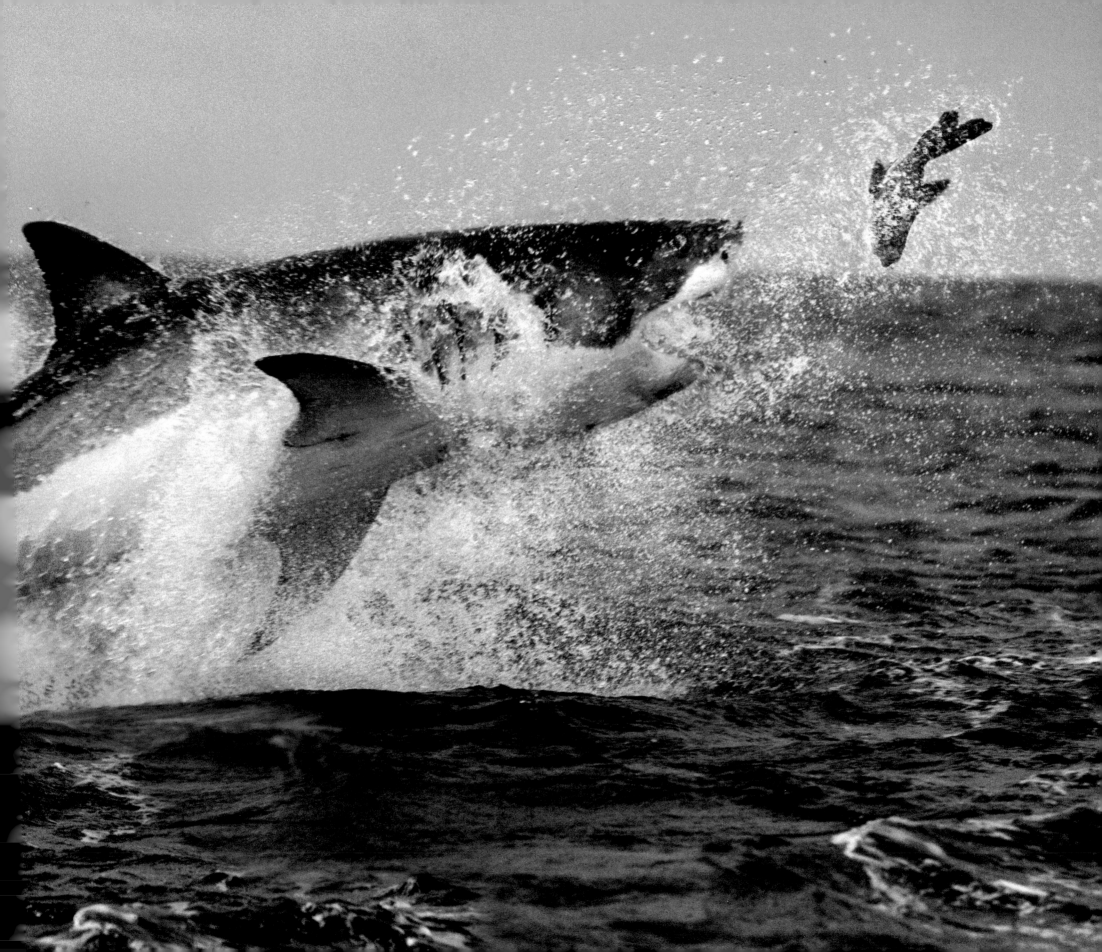

*Because the heart beats under a covering of hair,*
*of fur, feathers, or wings, it is, for that reason, to be of no account?*

JEAN PAUL RICHTER

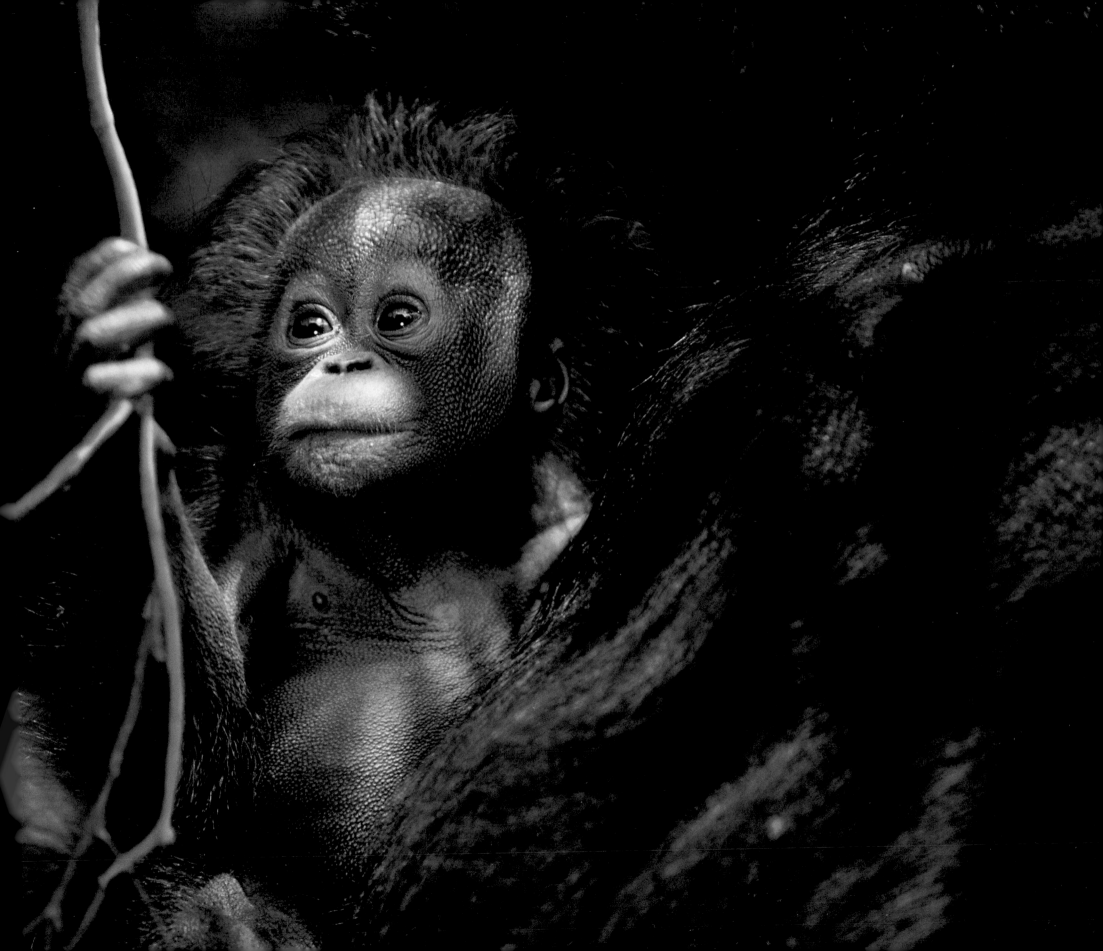

*God loved the birds and invented trees.*
*Man loved the birds and invented cages.*

JACQUES DEVAL

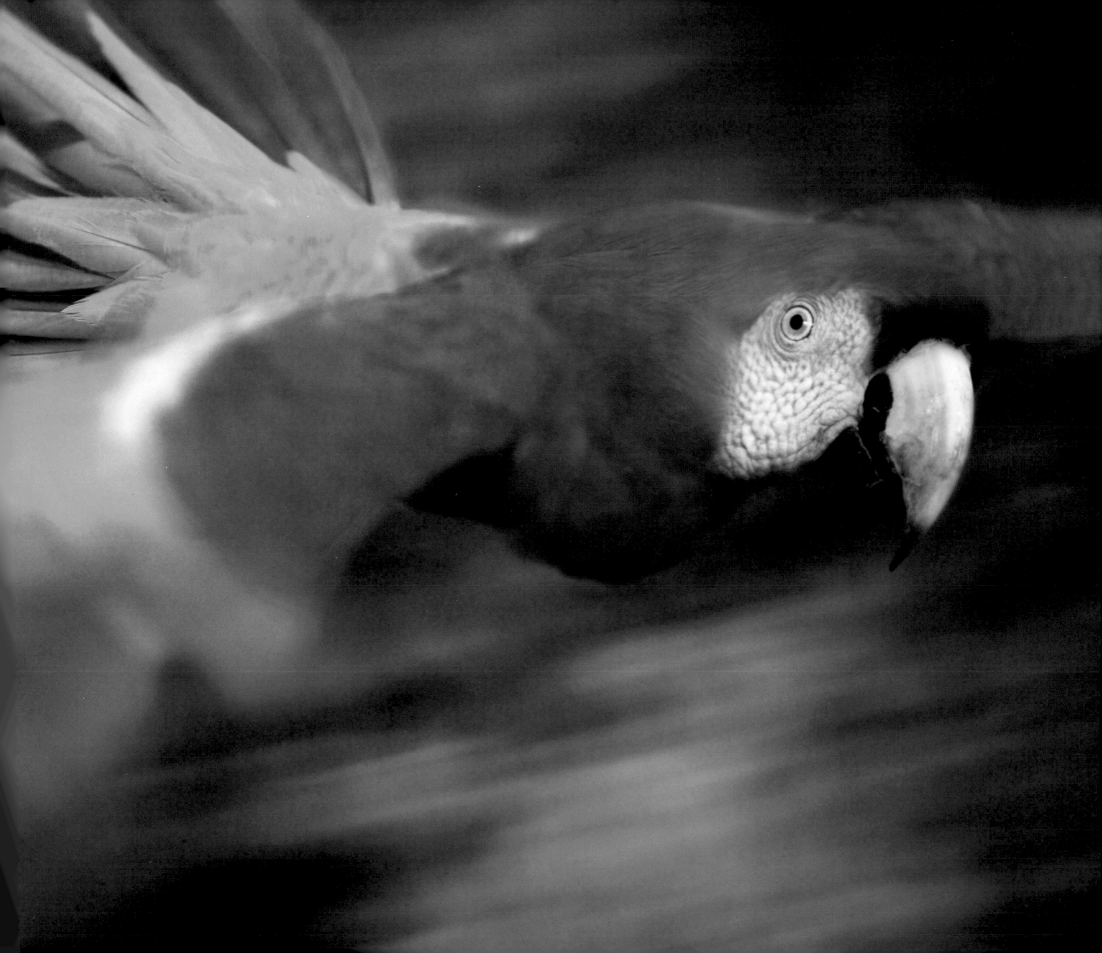

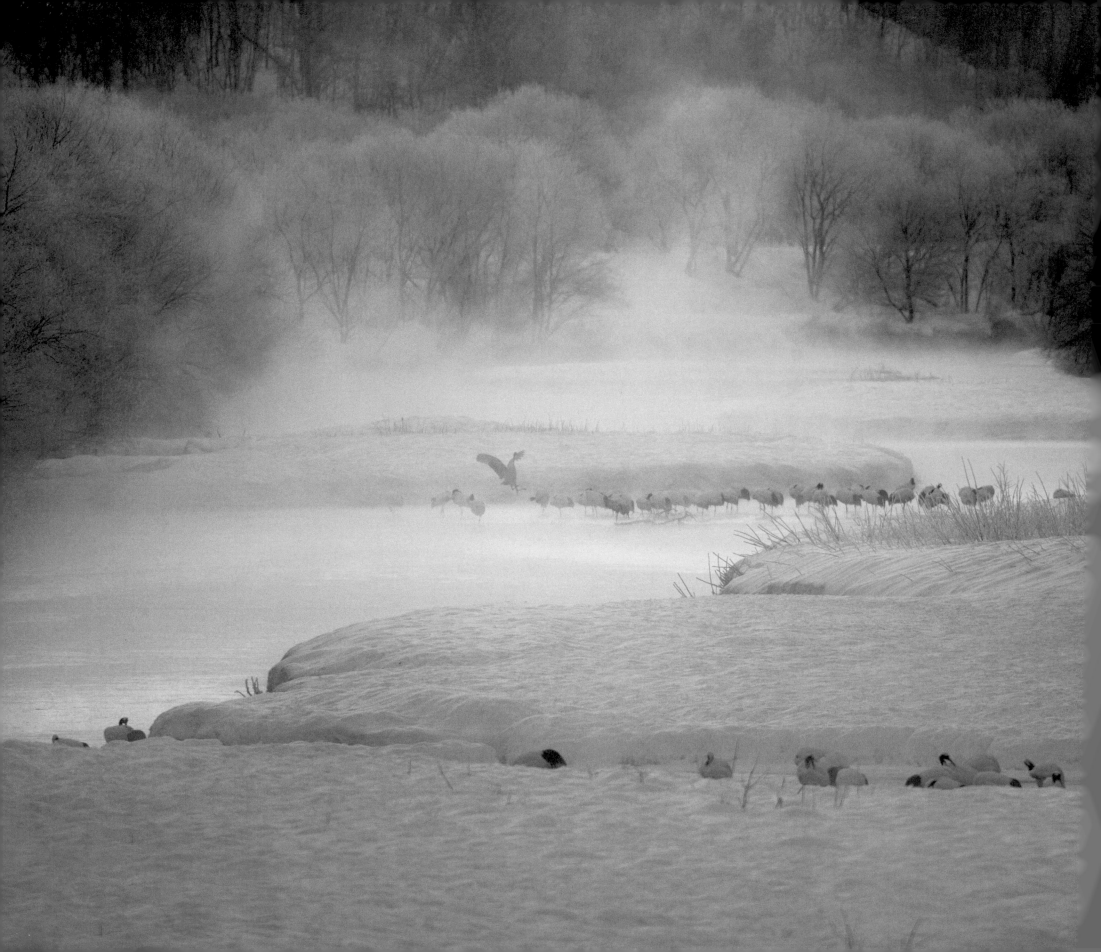

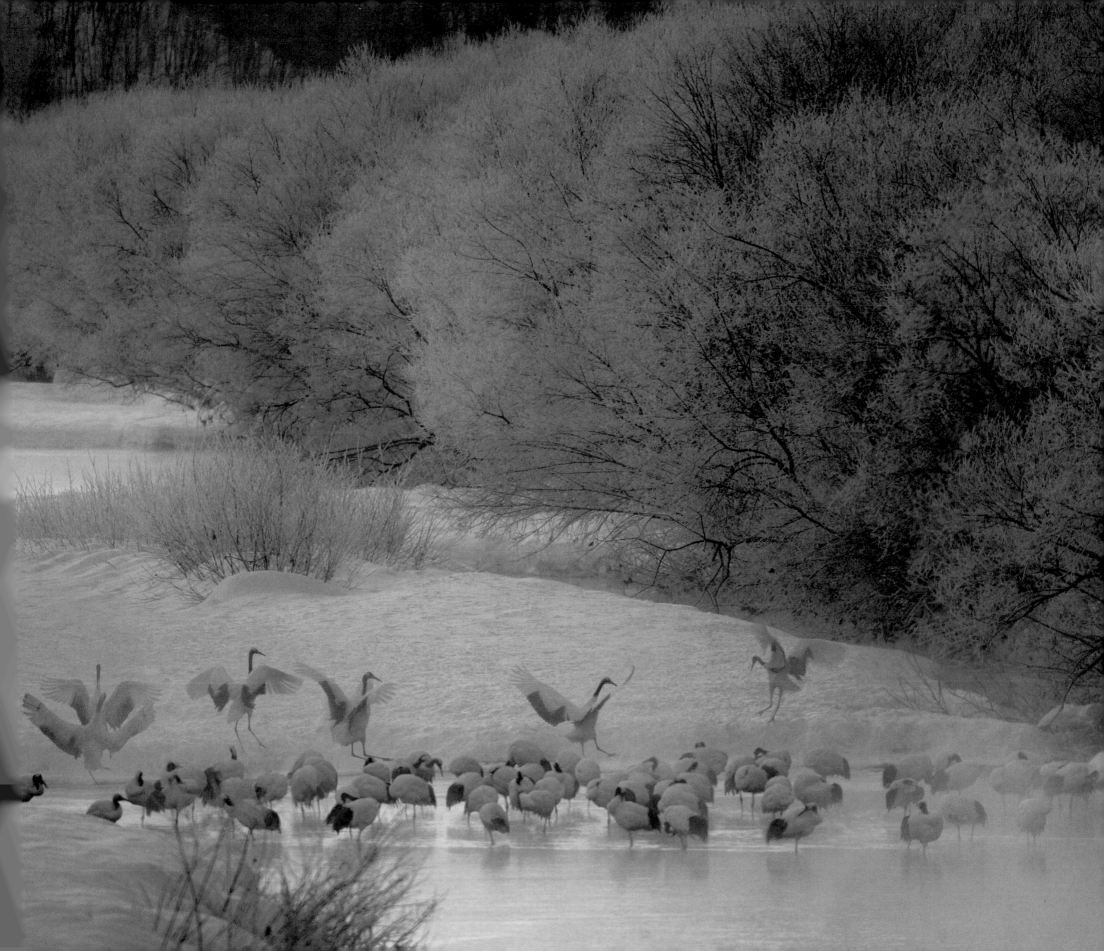

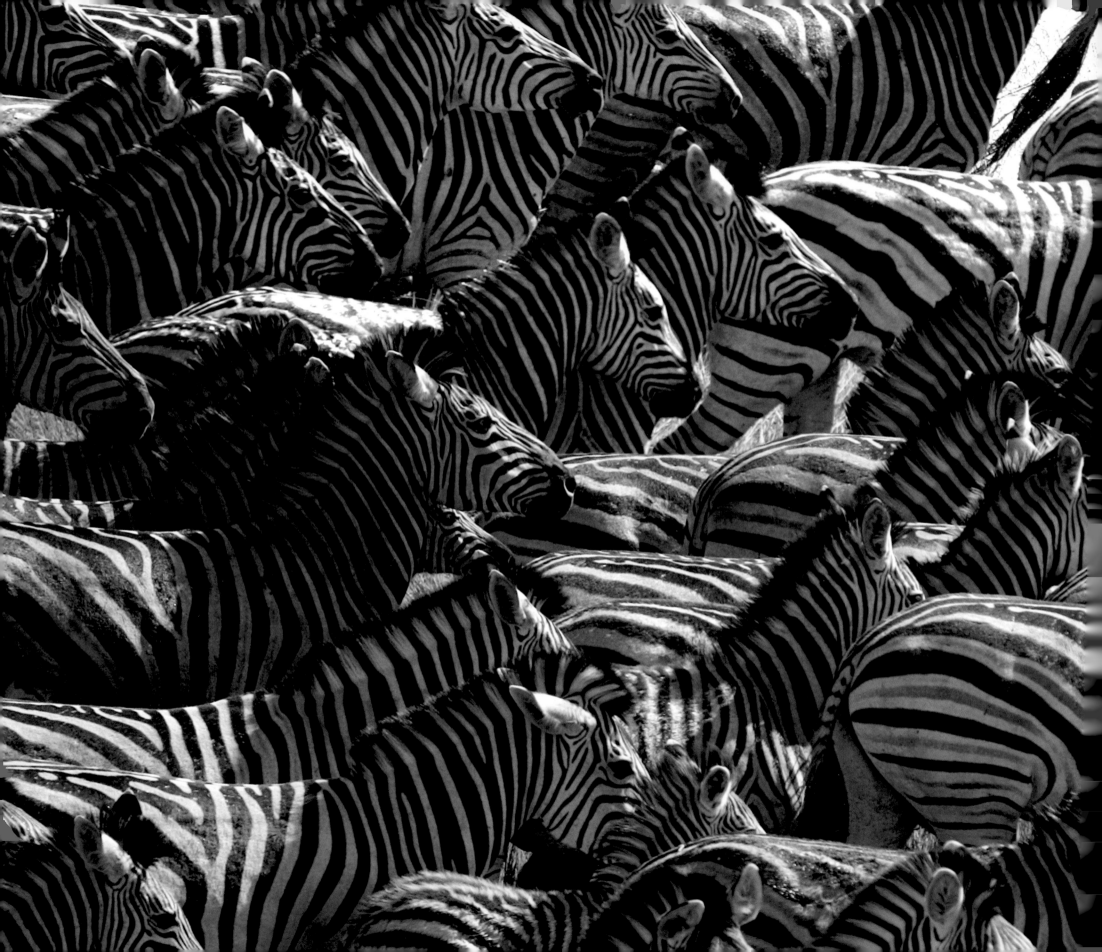

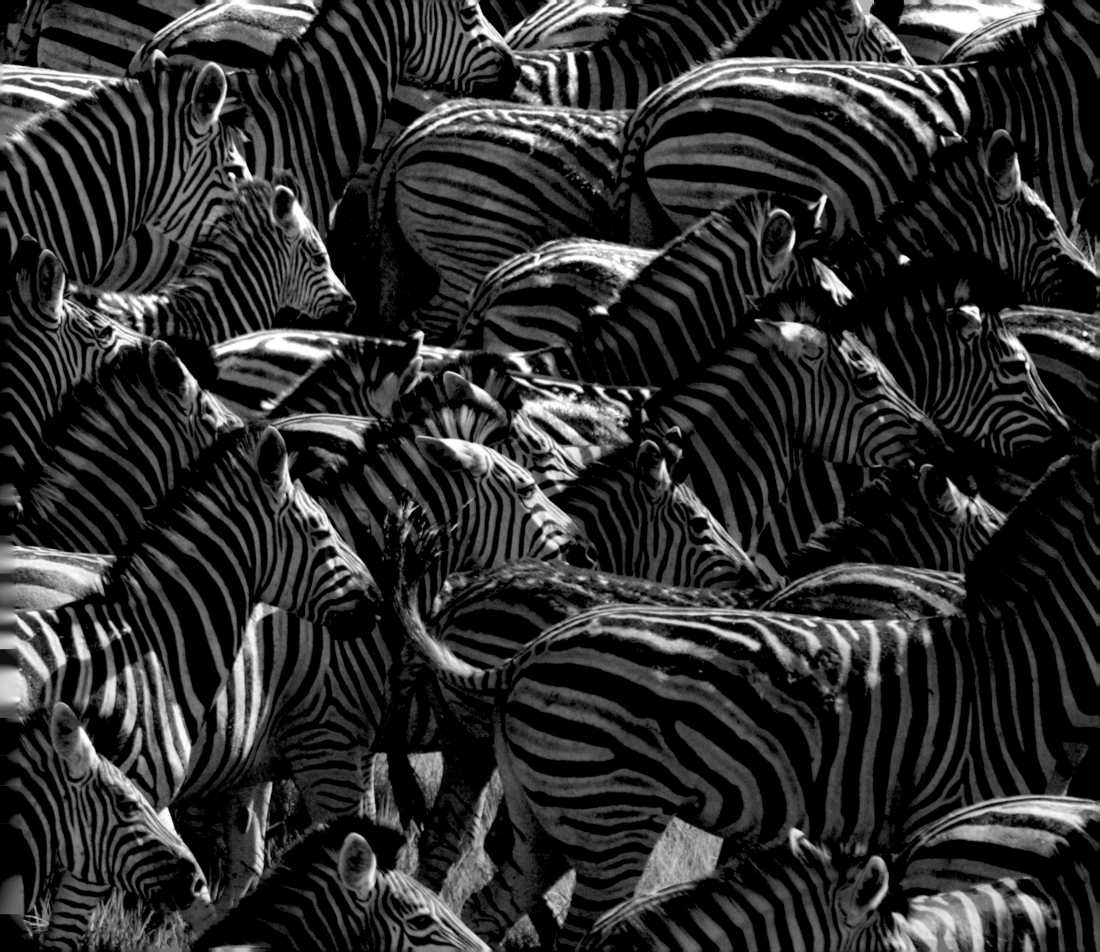

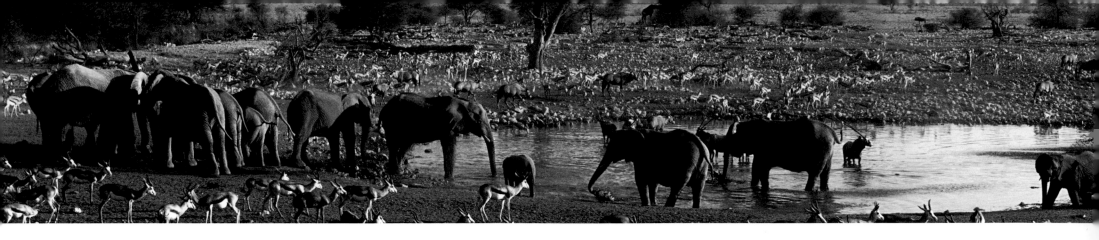

**The world is as delicate and as complicated as a spider's web. If you touch one thread you send shudders running through all the other threads. We are not just touching the web, we are tearing great holes in it.**

GERALD DURRELL

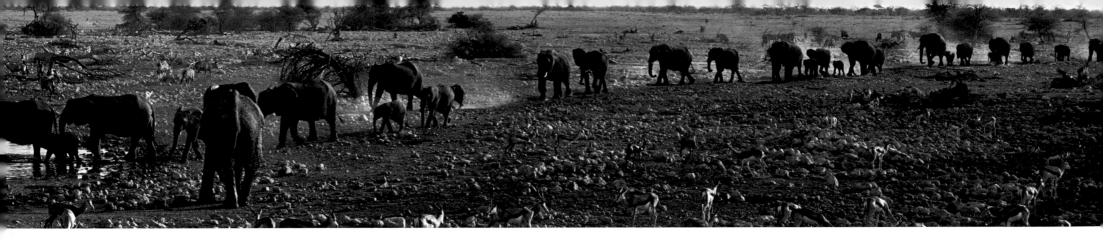

# THE IMPACT OF HUMANS

These poignant words by Gerald Durrell, written more than thirty years ago, have an even greater ring of truth today. I first read them at about the same time that a visit to a zoo had spurred me to search for, and photograph, great apes in their natural habitat. As I set off, my expectations were high and I believed I would discover wild and unspoiled paradises where apes lived undisturbed. I was unprepared for the disappointment that awaited me.

Travelling down the Sekonyer river in Borneo in search of orang-utans, I noticed that the water was strangely discoloured by poisonous mercury released into the water by mining activities further up stream – the very water on which the wildlife in the area depended. Shortly after my departure, forest fires started by illegal loggers spread to the area, with devastating consequences for the local wildlife. On another occasion, a trip to see the few remaining mountain gorillas in Central Africa was blighted by the sight of gorillas whose limbs had been amputated by trappers' snares. The more I travel the world, visiting remote places, the more I discover how we really are tearing apart the fabric of the Earth. In Antarctica, I had to be careful not to be in the sun for too long, for even in such an isolated region the ozone layer has been damaged by the activities of mankind, allowing too much ultra-violet light to penetrate the atmosphere in which the continent's wildlife lives.

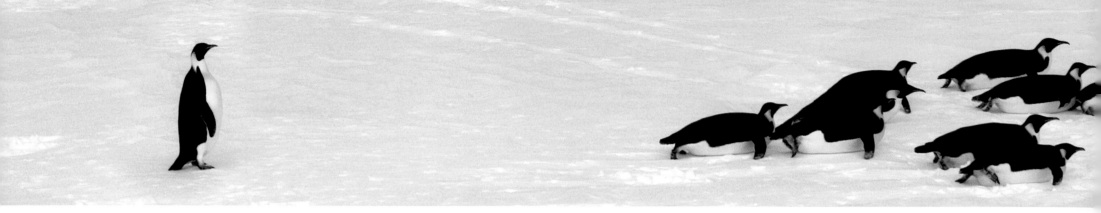

The impact of humans on the world is far more wide-reaching than most of us realize. When we look around, we see tangible evidence of our own negative actions on the environment. The excessive wrapping of consumer goods is but one example of the way we are contributing to the acceleration of the effects of global warming. My own local supermarket sells single items of fruit, sealed in hard plastic casings. The fruit, which may have been flown across continents at a considerable cost to the environment, is then passed through a manufacturing process in which non-degradable packaging is added to each piece, simply to make it more marketable. There is so much that can be done to retard the effects of our actions on the environment, and so little that is actually being done. A single item of fruit in its own wrapping may not be a significantly damaging act, but it is a small dent on the Earth. Repeated endlessly, these small acts accumulate and contribute to large-scale destruction.

It is easy to fall into the trap of assuming that certain animals are insignificant, but their value should never be underestimated, for there is much that we still do not understand about the ecological balance of the Earth. Who would have thought, for example, that the forest may depend on the fruit bat? The bat eats fruits, excretes the seeds, and spreads them widely so that new trees grow in different places, thus ensuring the natural sustainability of the forests. There are countless other such examples of the interdependence of

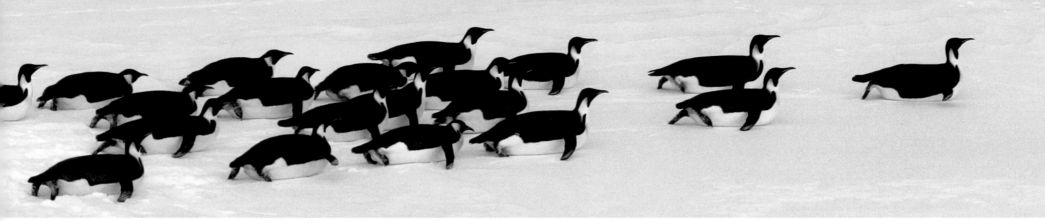

animals and plants where such relationships are essential for the maintenance of ecological equilibrium. By removing one creature from the cycle of life, others, too, may subsequently disappear.

There is enough evidence of ice melting in the polar regions to convince even the most hardened sceptic that changes are taking place. I was awestruck by the sight of the world's largest iceberg, roughly the size of Belgium, as it floated freely on a warm summer day in Antarctica. The vast mass towering above our icebreaker ship made me all too aware of the magnitude of the problems we face. While many speculate about the circumstances surrounding its break from the mainland, the consequence to local wildlife has been catastrophic. Emperor penguins have been forced to make massive detours in their search for food to bring back to their chicks and an unusually high number of chicks have died as a result.

While the increase in global temperatures has seriously affected the world's wildlife, the widespread distribution of pollutants is further adding to the problem. River, air and ocean currents carry pollutants thousands of miles from industrial countries to the once-pristine Arctic, where they are trapped in the ice and then slowly released back into the environment. These pollutants pass through the food chain, hence the high concentrations found in Arctic foxes and polar bears. Environmental problems are exacerbated by a combination of the early melting of ice, and the concentration of matter which destroys the purity of the Arctic.

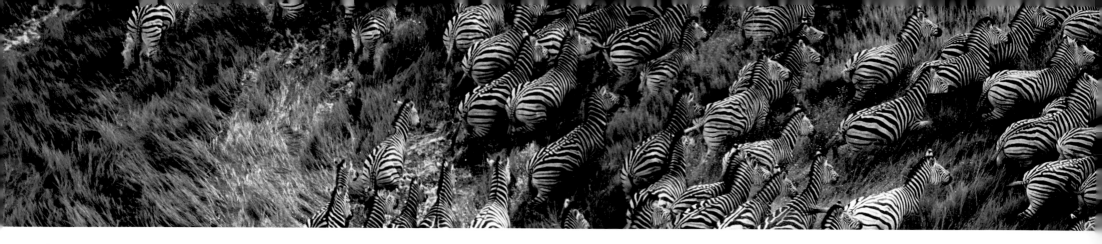

The polar bears of Canada's Hudson Bay use the frozen sea as a platform from which to hunt seals. The bears are most successful at catching seals on the ice, targeting breathing holes and waiting for the seals to surface for air. It is much more difficult for bears to catch seals in open water. In recent years, rising temperatures have caused the ice to melt earlier, thereby reducing the bears' hunting time. It is a delicate balance, and the polar bear population has been steadily declining in the area.

In contrast to polar areas, tropical rainforests encircle the Earth in a band along the equatorial regions. They are the lungs of the planet, using photosynthesis to process carbon dioxide and produce oxygen. They provide our greatest single territorial source of breathable air. Surprisingly, tropical rainforests comprise only about two per cent of the surface of the Earth, yet they are home to two-thirds of the Earth's living creatures. Their plants are used to make nearly half of our medicinal products. They are a vital resource and absolutely essential for our long-term survival.

It is estimated that every second, more than an acre and a half of rainforest is being destroyed. Unless we stop this destruction, by the middle of the century, there will hardly be any forests left, and countless animals will become extinct. There are many underlying causes of deforestation and habitat encroachment, such as logging, overpopulation, poverty, agriculture and industrial development. Together, all these factors add up to the wholesale damage of the

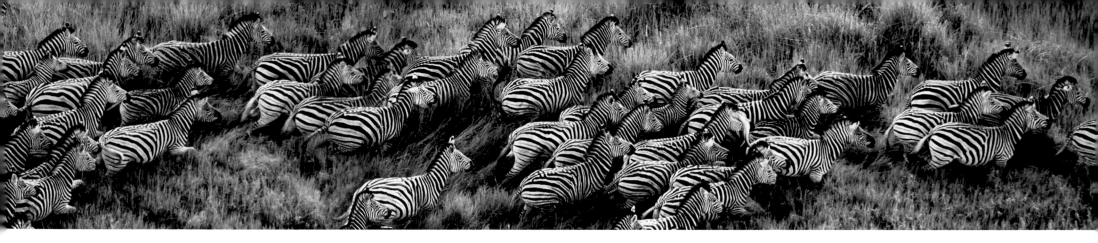

environment and all the creatures that live in it, including humans. So what can each one of us, as individuals, do about contributing to a reversal of the damage that people have caused?

The first step is to be mindful of the consequences of our personal actions. Think about what we are doing, become more conscious of our own impact and spread the word to other people. Recycling helps reduce carbon emissions. I am proud to live in one of the most energy-efficient towns in Britain. It has an extensive recycling programme, so that rubbish collections take place only once a fortnight, with a seventy-five per cent reduction in household waste. If you must have a car, buy a fuel-efficient one, and think of the money you will save. You can also avoid using your car for short trips. Walk or cycle where possible, and become healthier in the process. Insulate your home and install solar panels: they will pay for themselves in the long-term. Use energy-efficient appliances and light bulbs, turn off the tap while brushing your teeth, and switch off the lights when leaving a room. There is so much that can be done without reducing our standard of living, and so much more that can be done if we can only learn to adapt.

We are all part of nature, and each injury to it, results in an injury to ourselves. By living without fear of the wildness in the world, and by acting with a social conscience, we will provide security for generations to come. The sacrifice is small: the rewards are immeasurable.

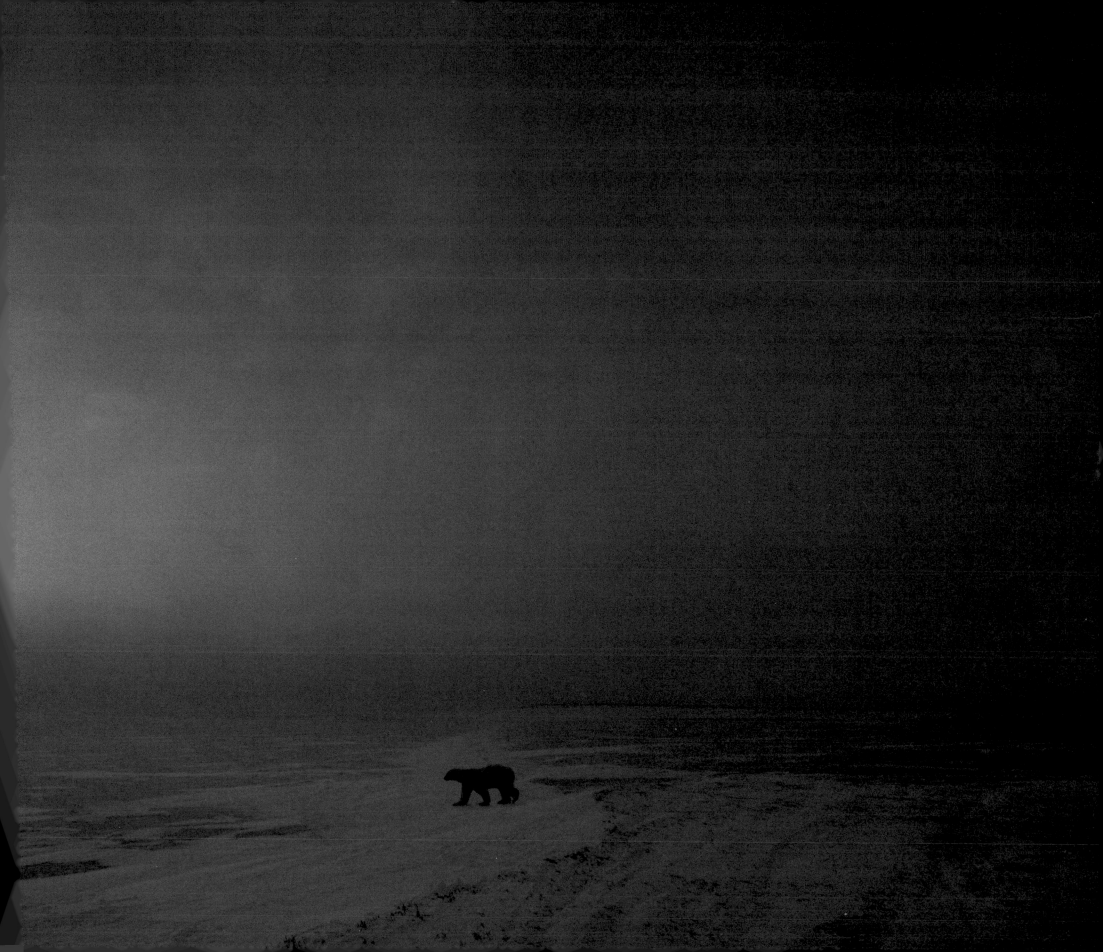

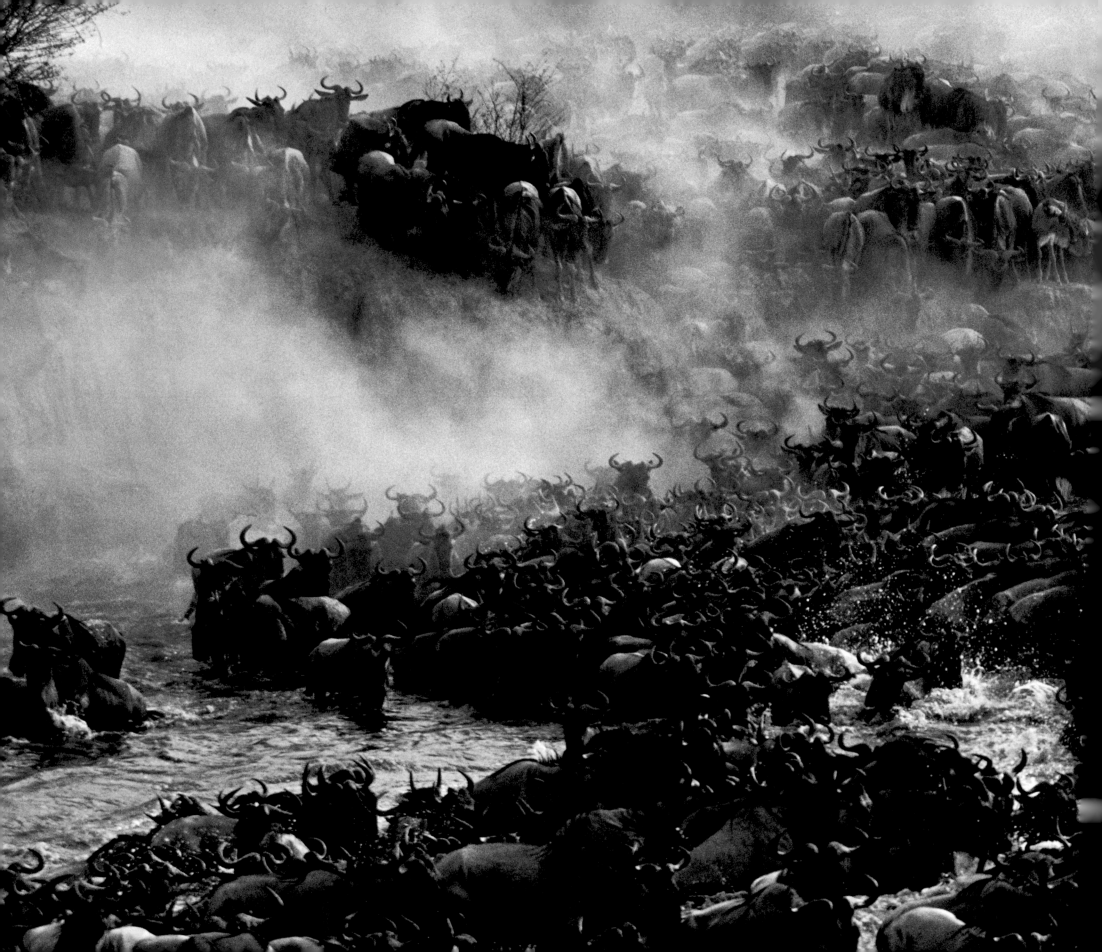

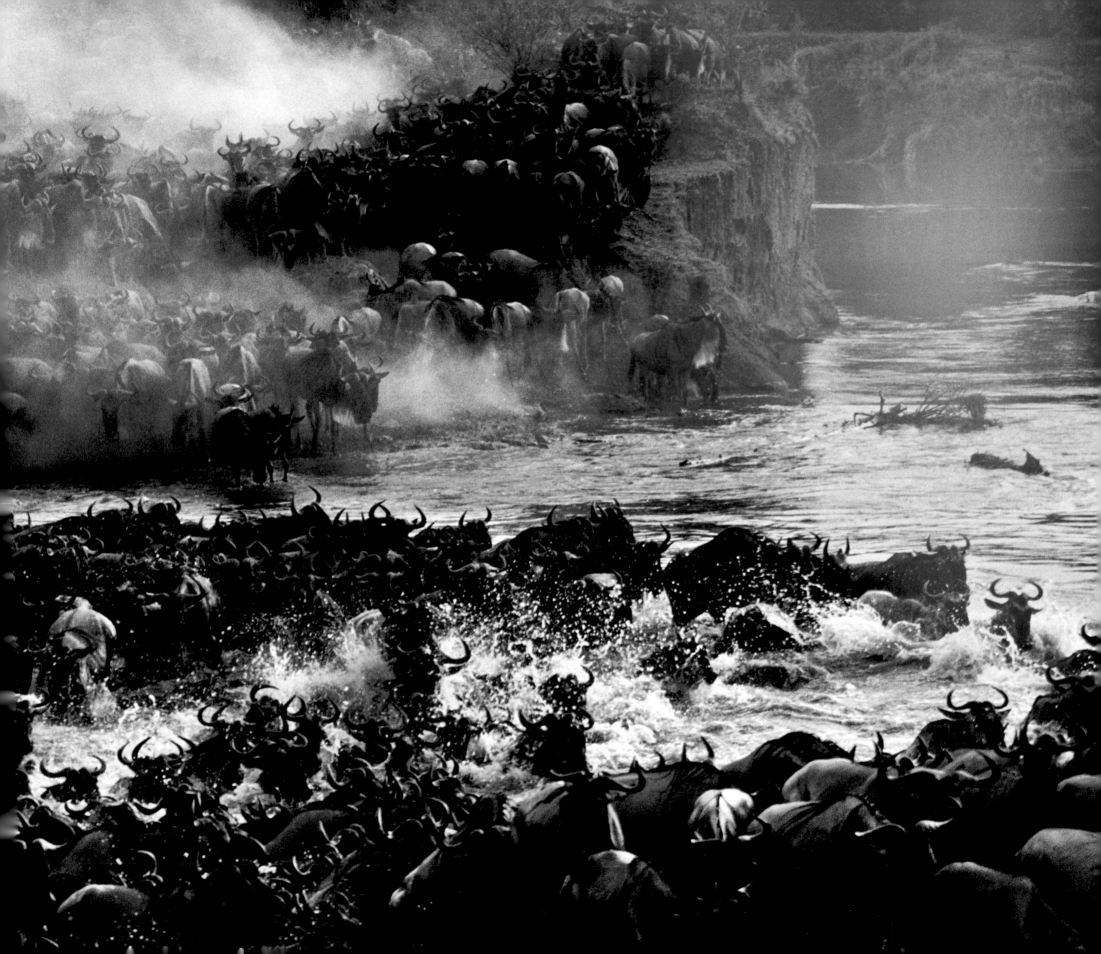

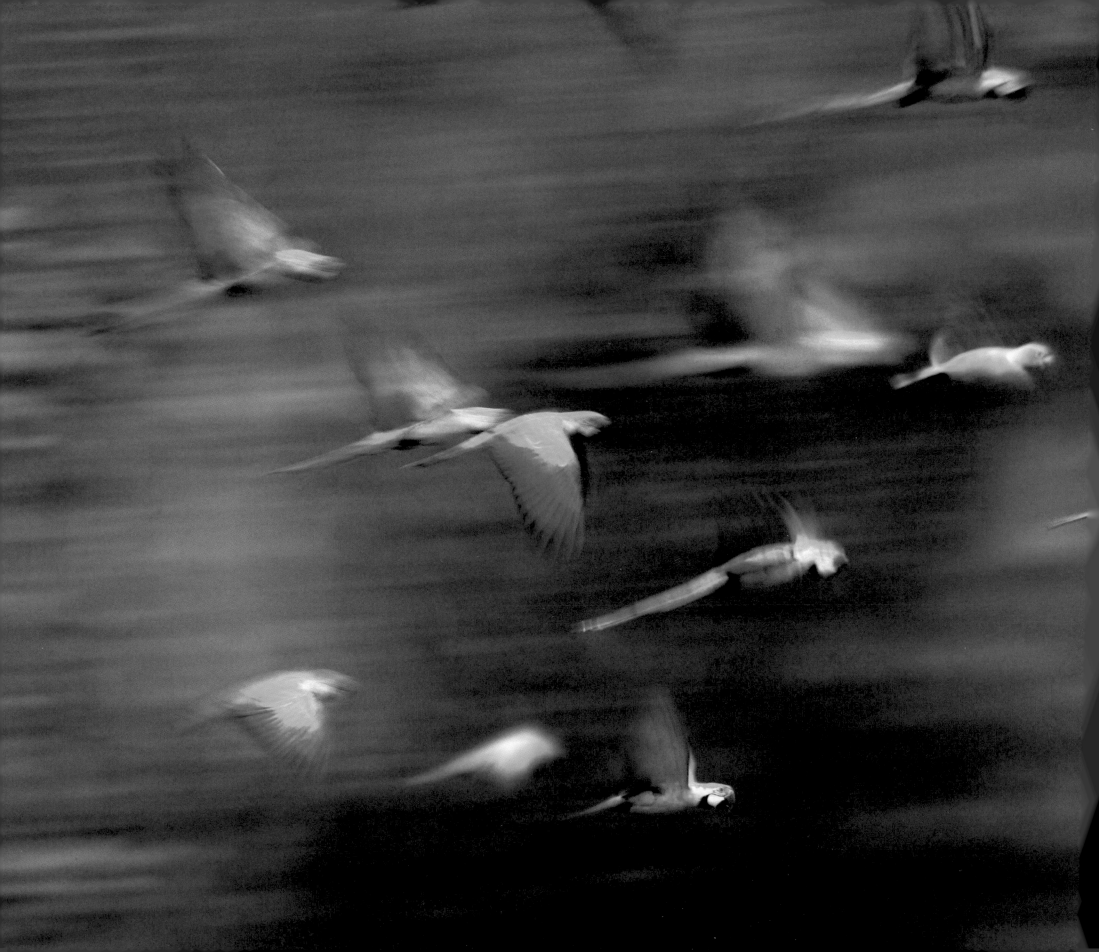

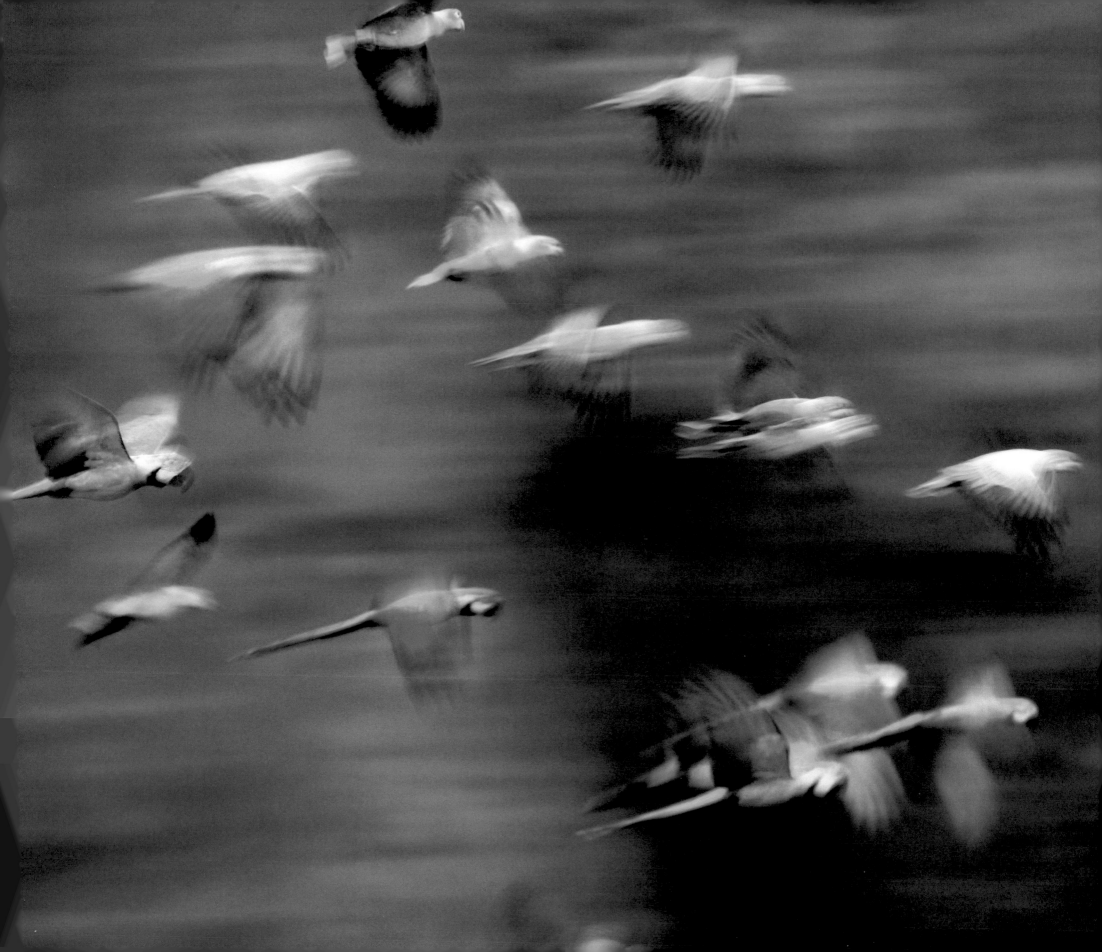

*Animals are such agreeable friends: they ask no questions,*
*they pass no criticisms.*

GEORGE ELIOT

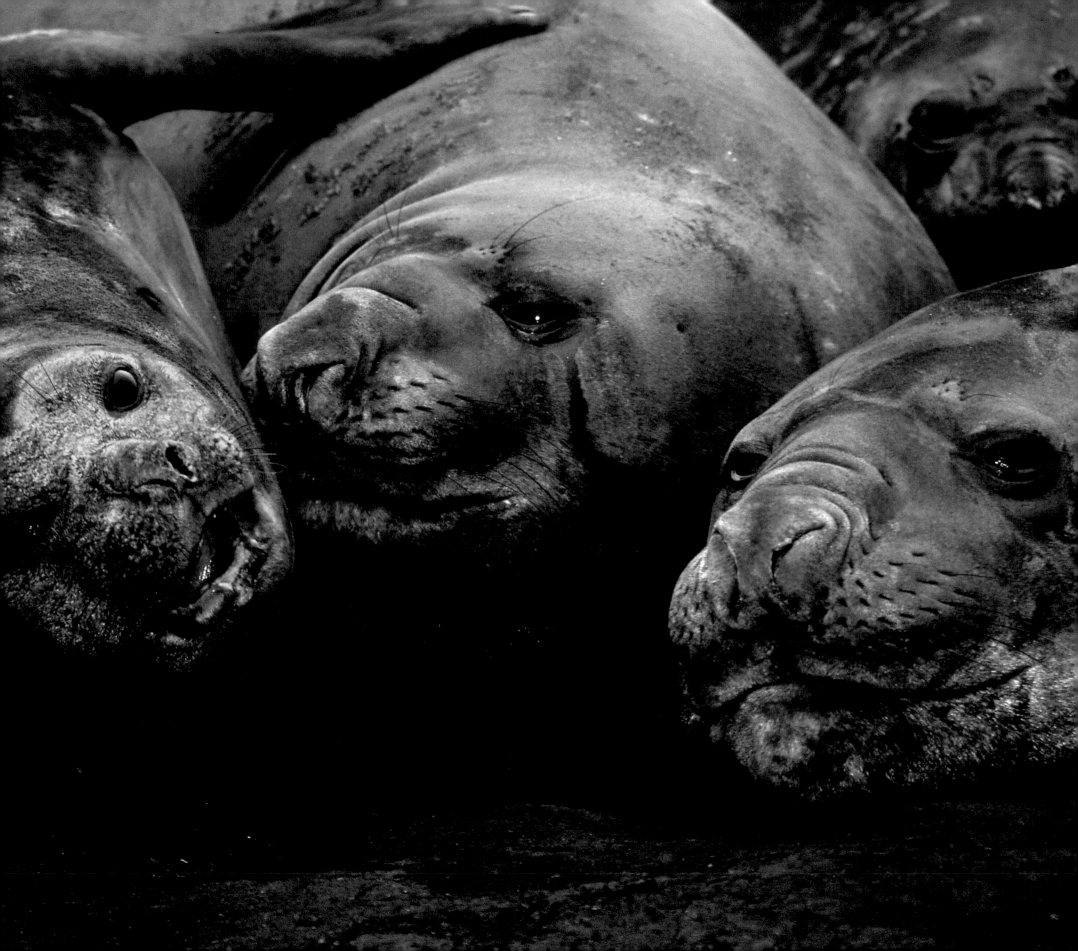

*The basis of all animal rights should be the Golden Rule:*
*we should treat them as we would wish them to treat us,*
*were any other species in our dominant position.*

CHRISTINE STEVENS

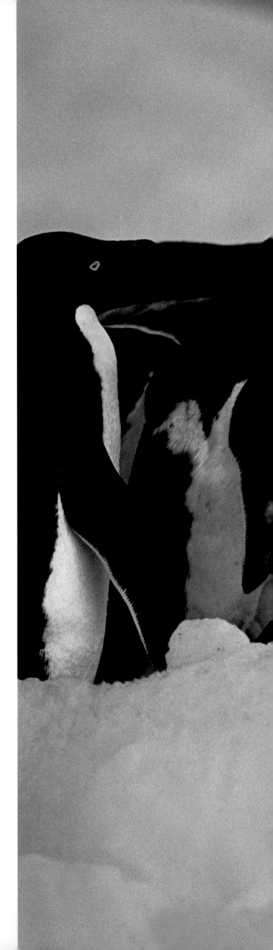

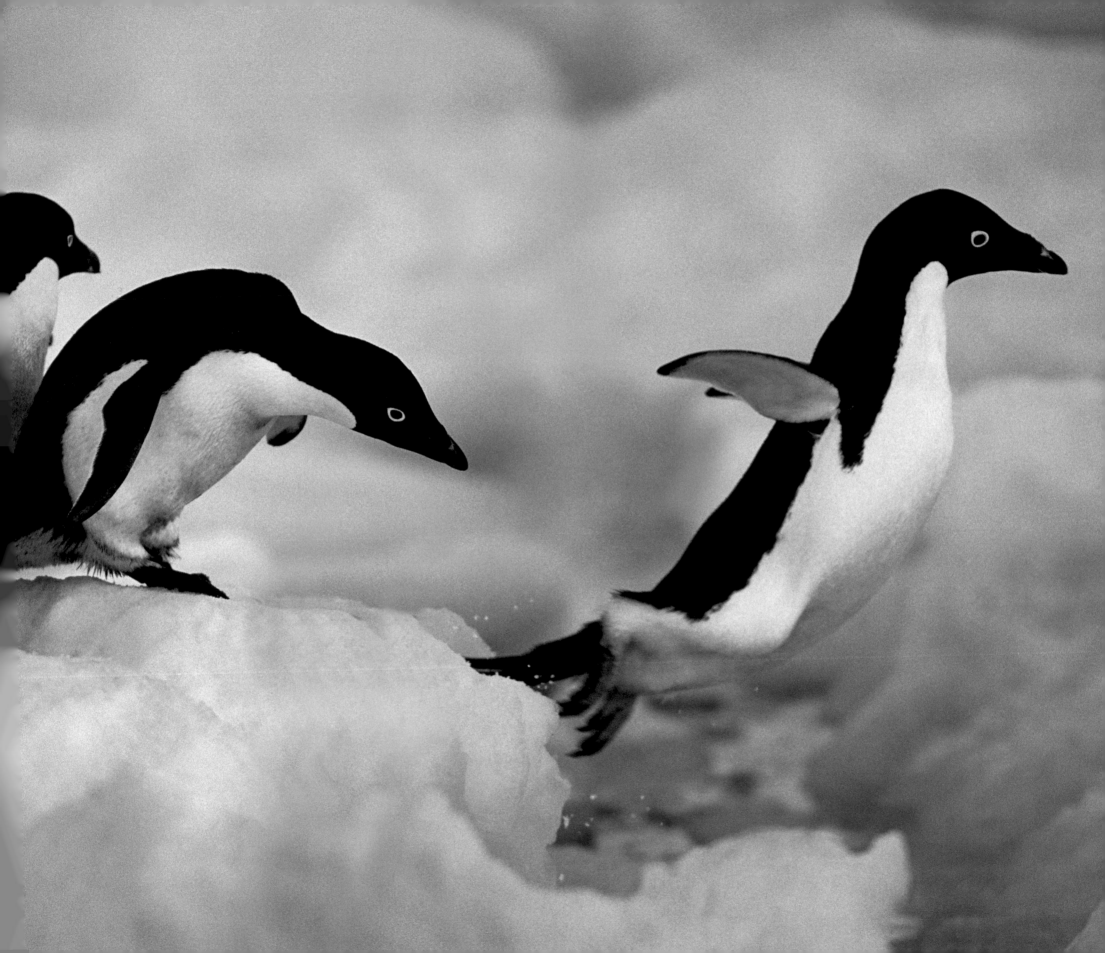

*It is an important and popular fact that things are not always what they seem. For instance, on the planet Earth, man had always assumed that he was more intelligent than dolphins because he had achieved so much – the wheel, New York, wars and so on – whilst all the dolphins had ever done was muck about in the water having a good time. But conversely, the dolphins had always believed that they were far more intelligent than man – for precisely the same reasons.*

DOUGLAS ADAMS

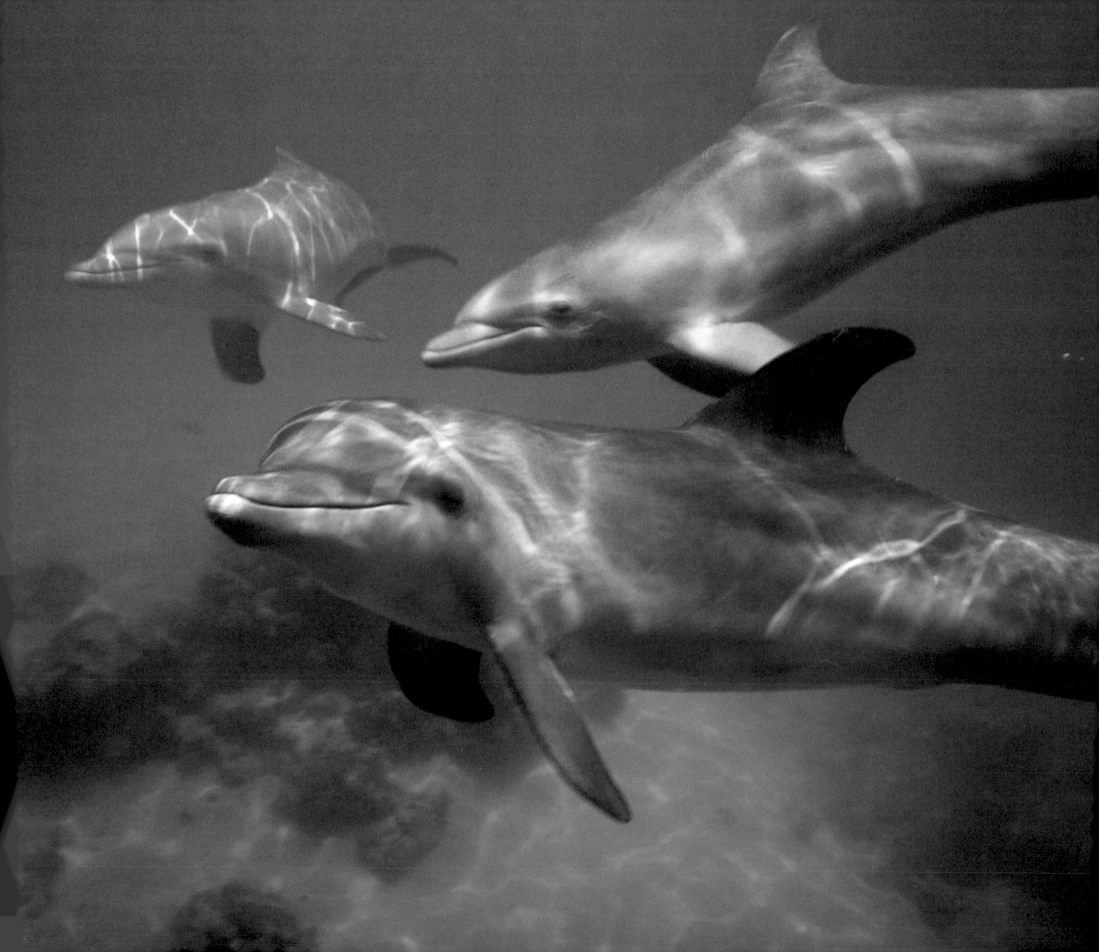

*Nature's great masterpiece, an elephant;*
*the only harmless great thing.*

JOHN DONNE

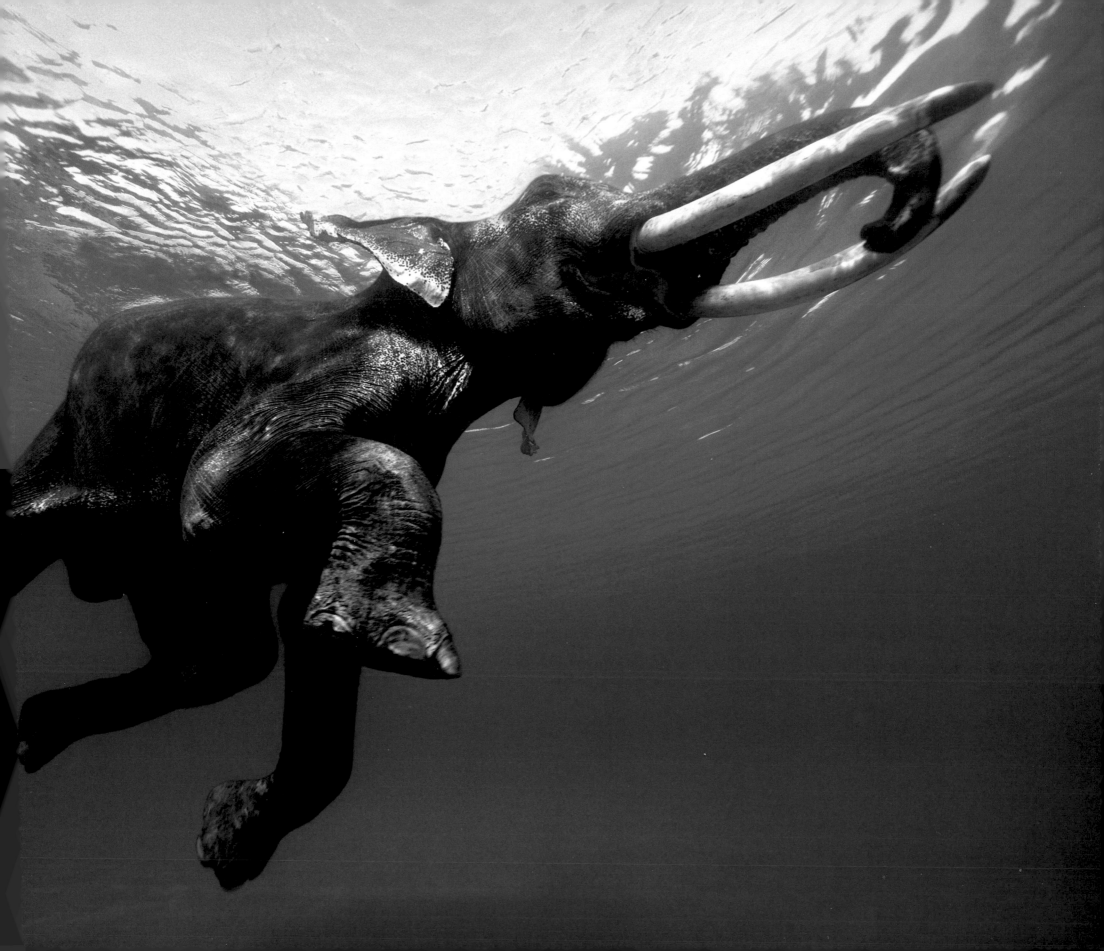

Non-violence leads to the highest ethics,
which is the goal of all evolution.
Until we stop harming all other living beings,
we are still savages.

THOMAS A. EDISON

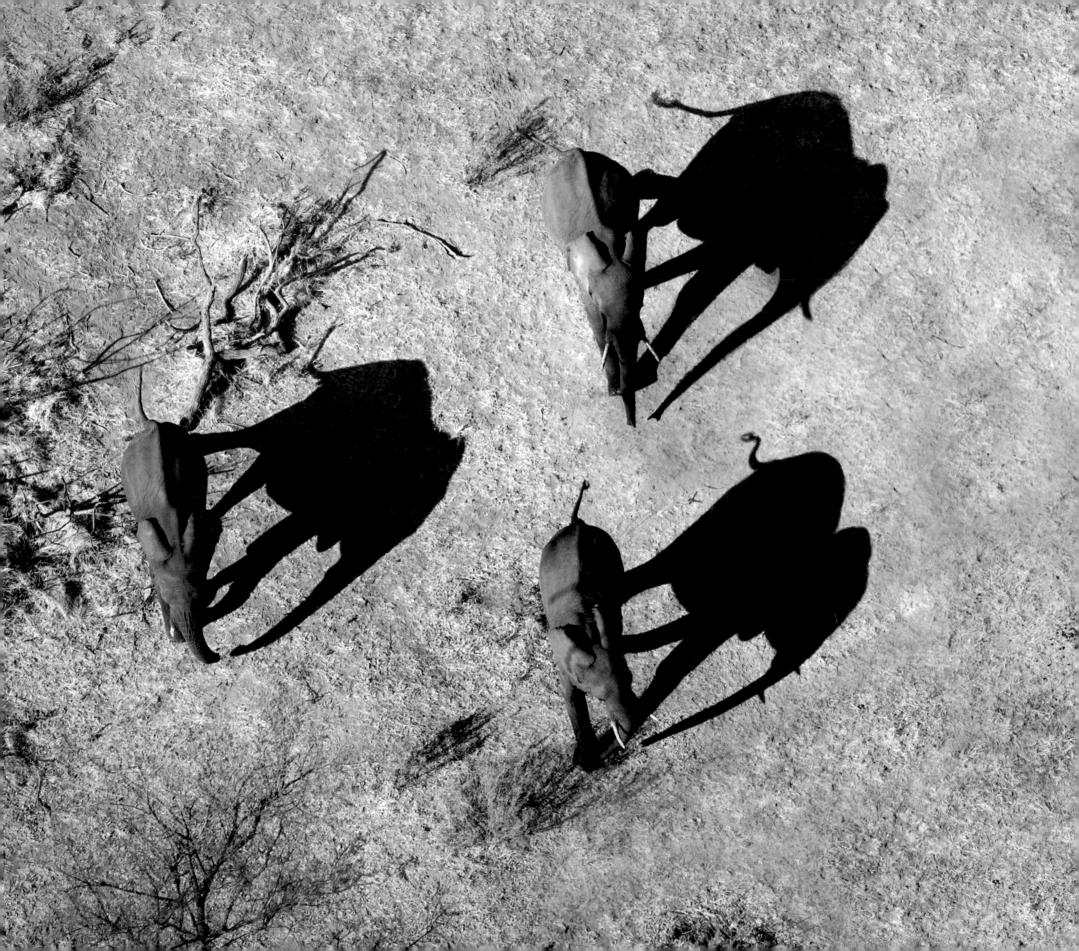

*All animals are equal*
*but some are more equal than others.*

GEORGE ORWELL

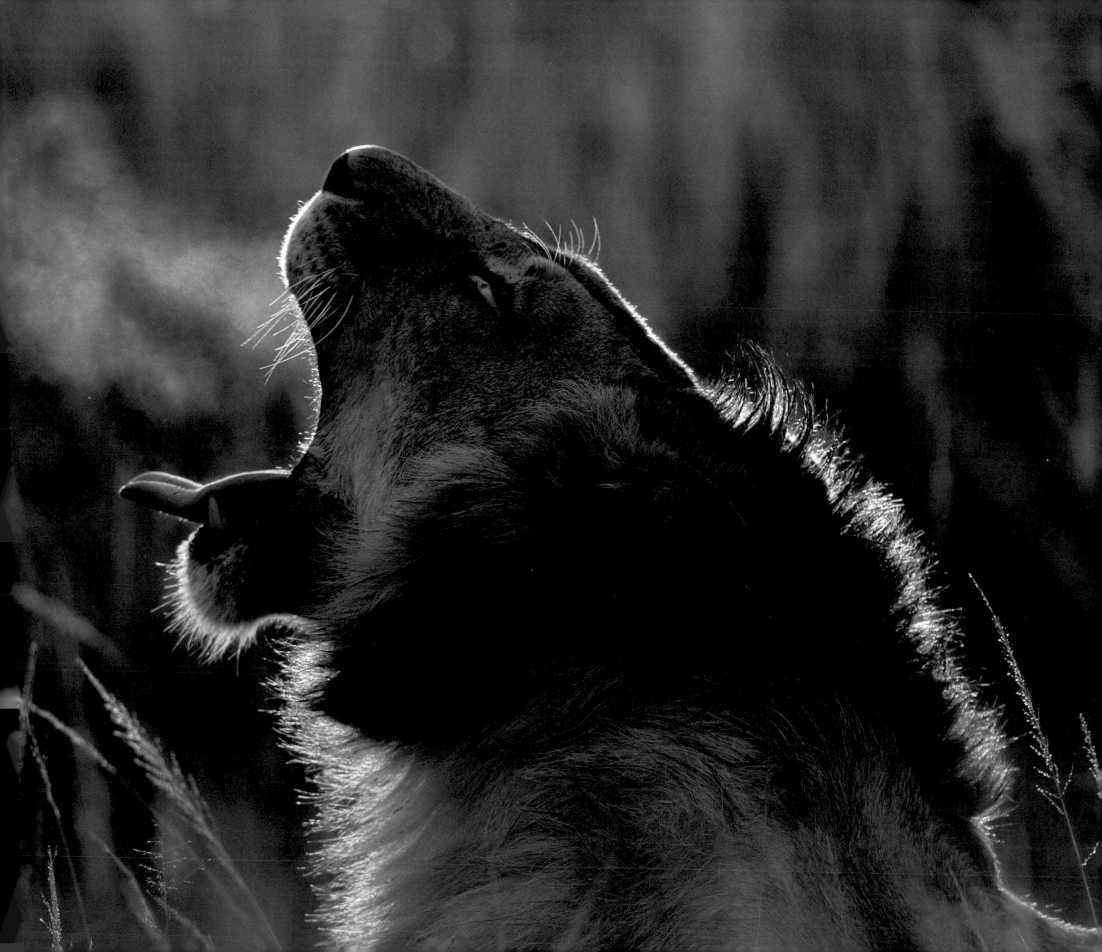

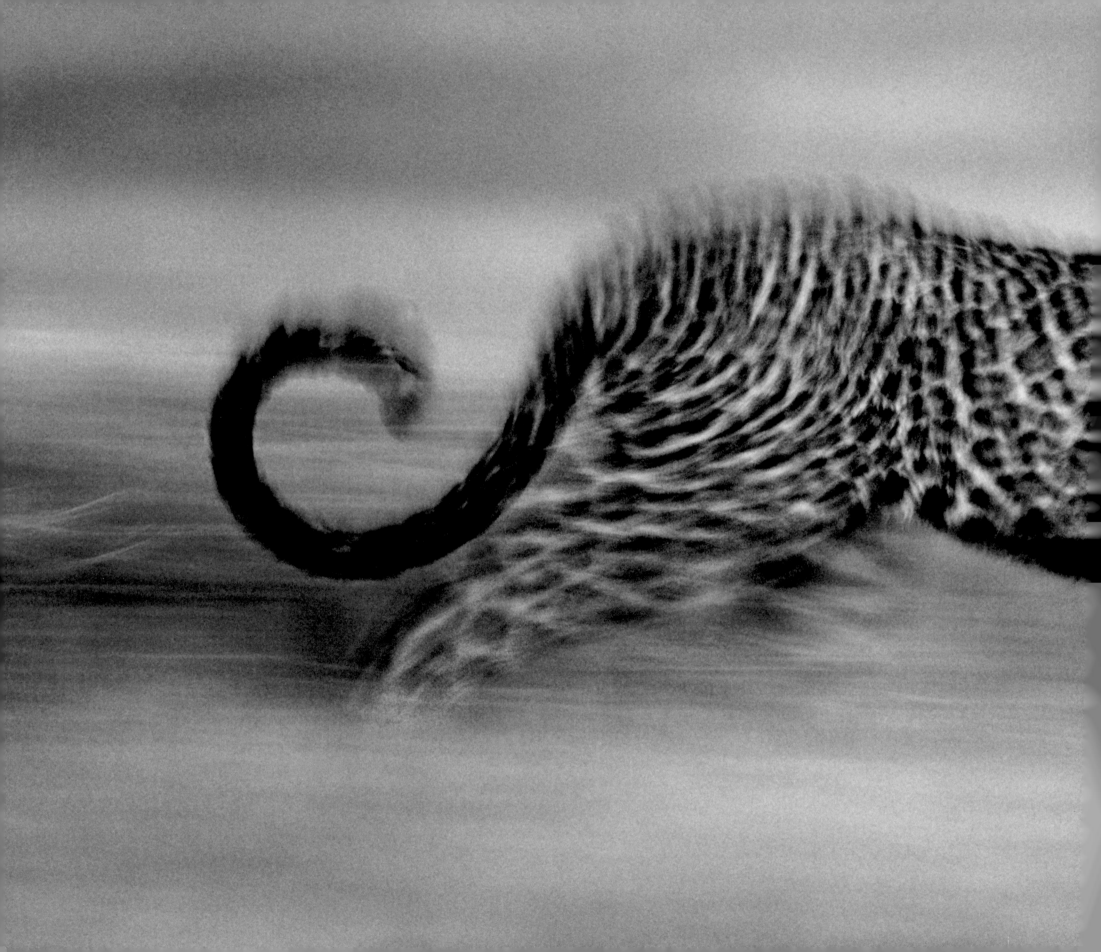

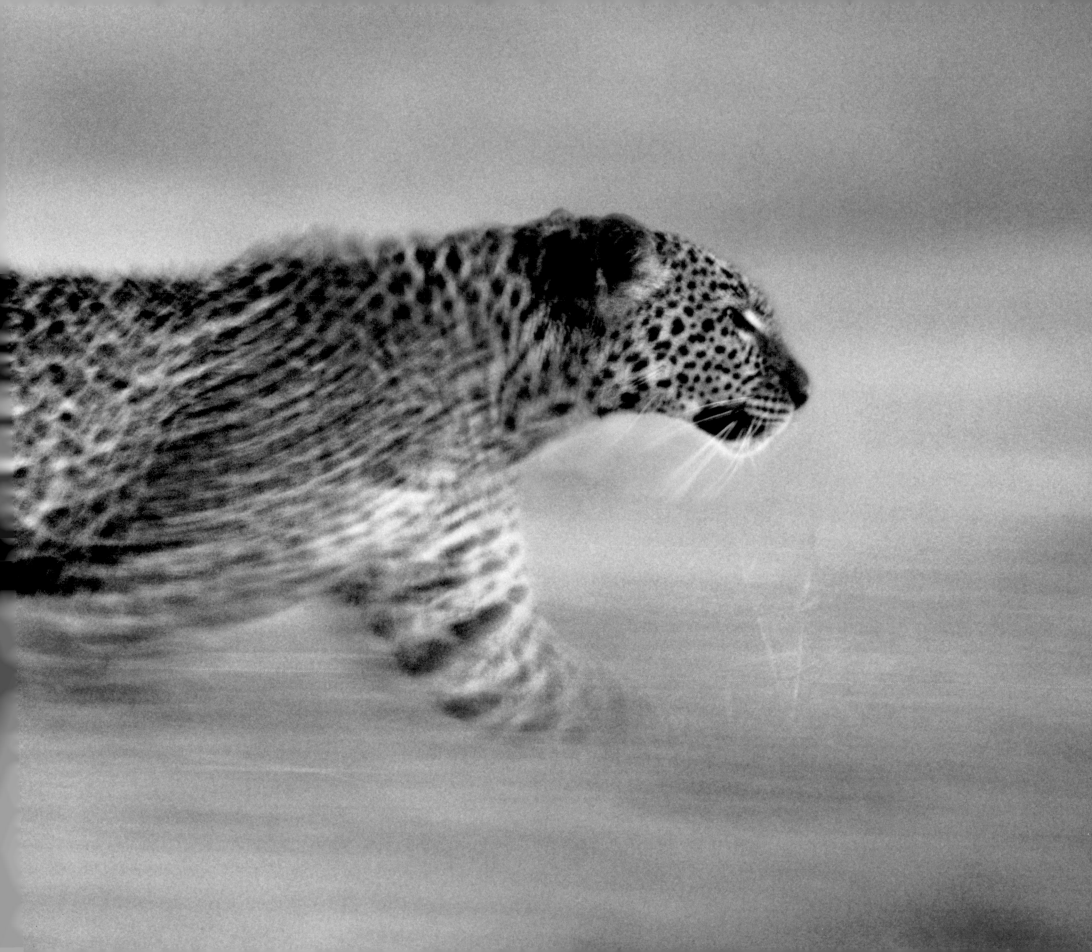

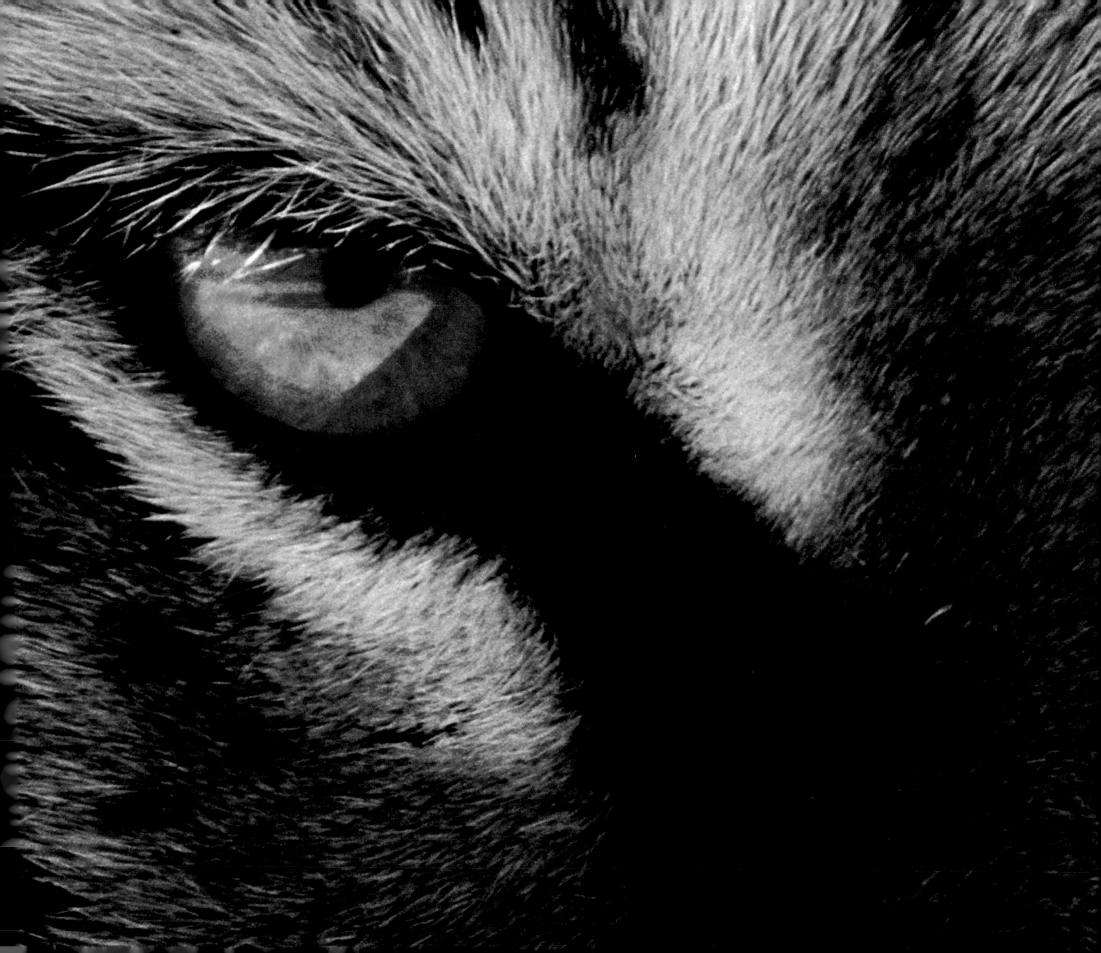

*Animals, whom we have made our slaves,*
*we do not like to consider our equal.*

CHARLES DARWIN

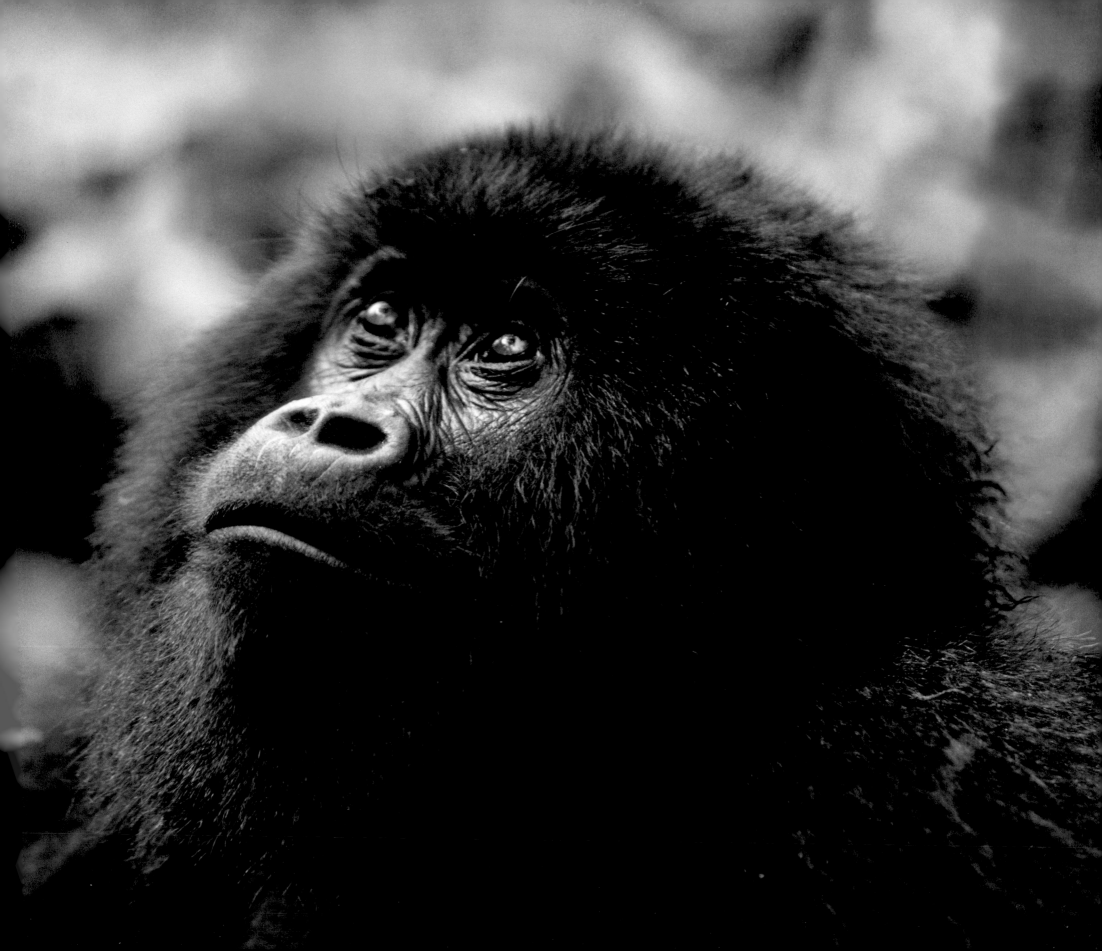

*The assumption that animals are without rights and the illusion*
*that our treatment of them has no moral significance*
*is a positively outrageous example of Western crudity and barbarity.*
*Universal compassion is the only guarantee of morality.*

ARTHUR SCHOPENHAUER

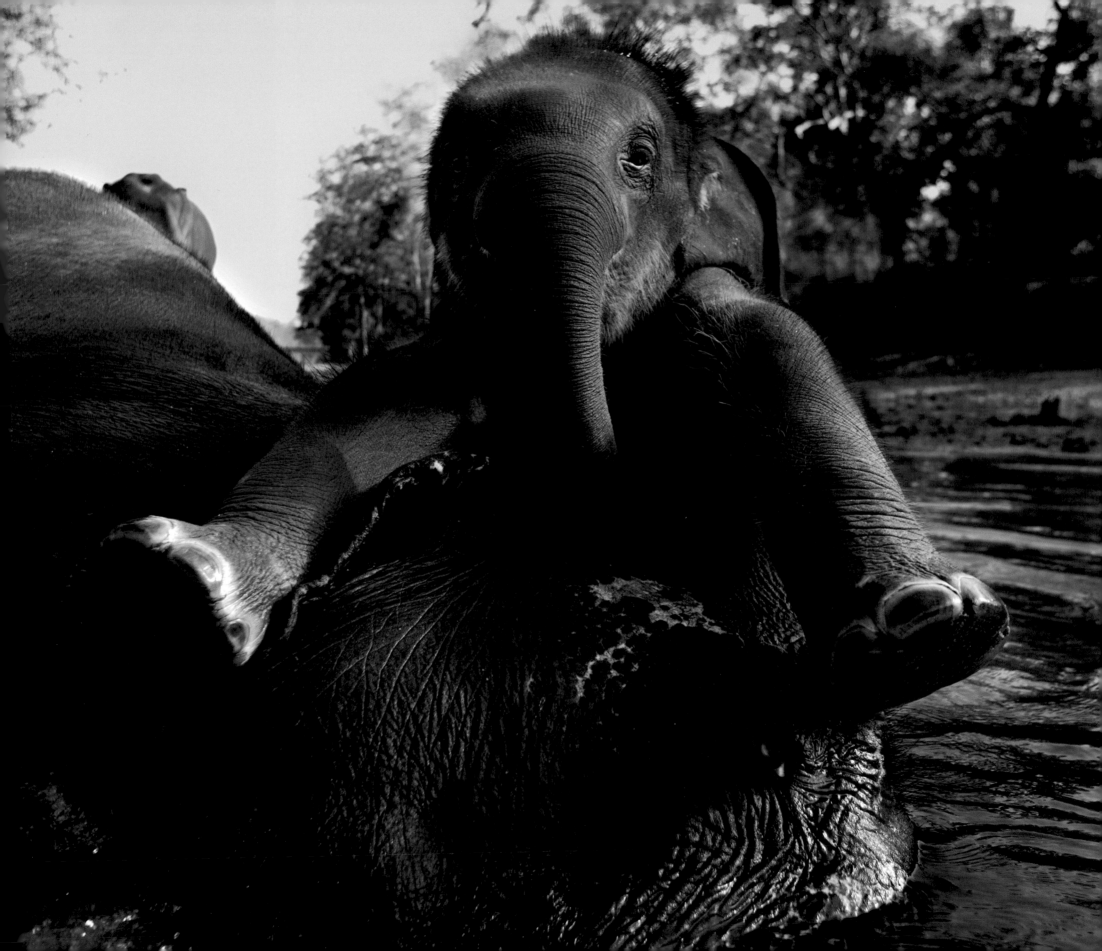

It should not be believed that all beings exist for the sake
of the existence of man. On the contrary,
all the other beings too have been intended for their
own sakes and not for the sake of anything else.

MAIMONIDES

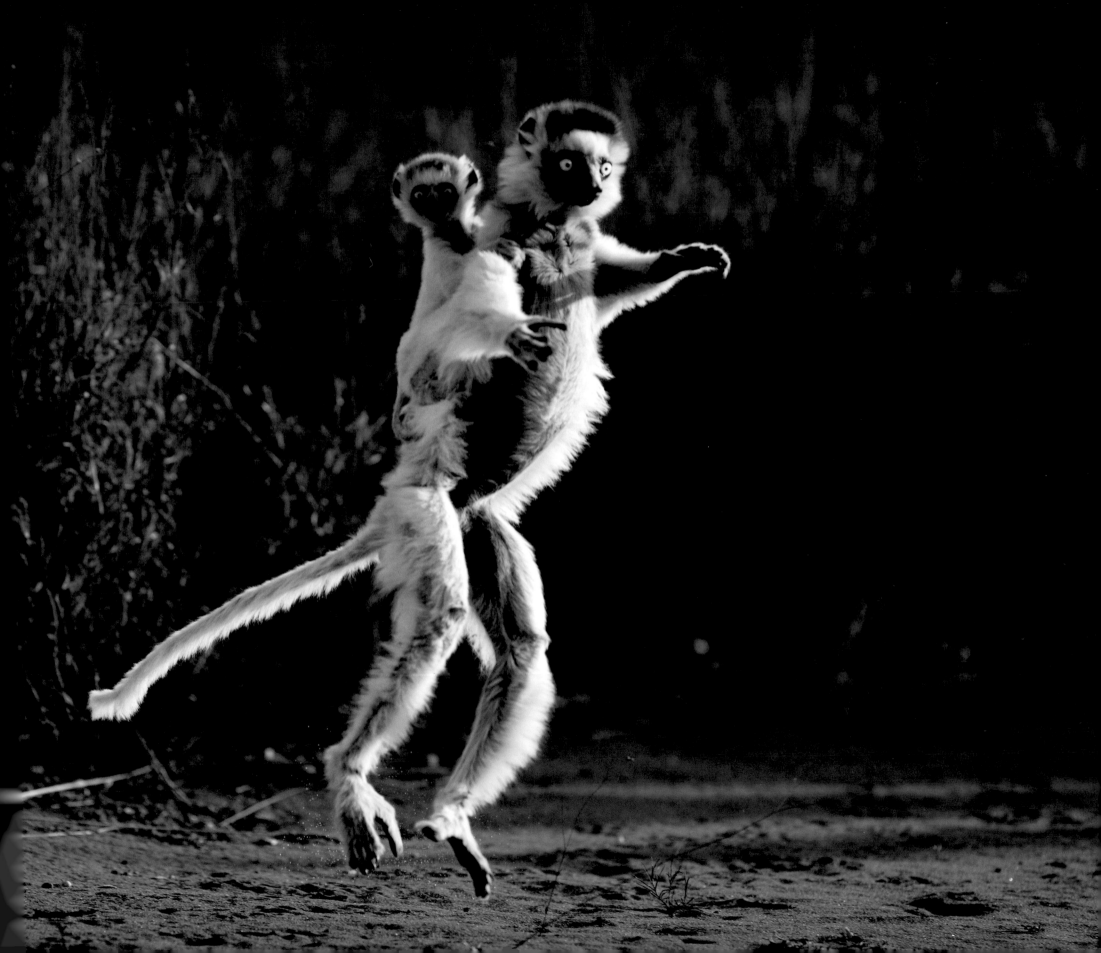

When the singer Eva Cassidy was terminally ill, she attended a tribute concert in which she bravely took the podium and sang 'What a Wonderful World'. She was so ill and racked with pain she could barely move, yet she sang with haunting beauty, and the recording of her voice has touched millions. It was the last song she ever sang in public.

In a world bruised and battered by wars, famine, natural disasters and global warming, it is often hard to see through the fog. Most of our energies are taken up by the day-to-day process of surviving, yet the world truly is wonderful, that is, if we allow it into our hearts. Louis Armstrong saw it, sang about it and passed it on to others.

A journalist once asked me why we should care if tigers become extinct. After all, they don't impact on our daily lives. I thought for a moment, then replied that there are many songs we have not yet heard, songs which do not impact on our daily lives, yet the death of music would be a violation of our souls. The world is a pool of diversity, and we reach into it with our senses, thoughts and deeds. It is said that we borrow the world from our children, and have a duty of care to uphold. Those who have the rare privilege of seeing a tiger in the wild are enriched by the experience. We search for the antithesis of what we believe to be wrong in the world, continually striving to kindle a light in the darkness. By opening our eyes, hearing nature's music and acting with greater responsibility, we can and will nourish our own spirits and truly think to ourselves: what a wonderful world.

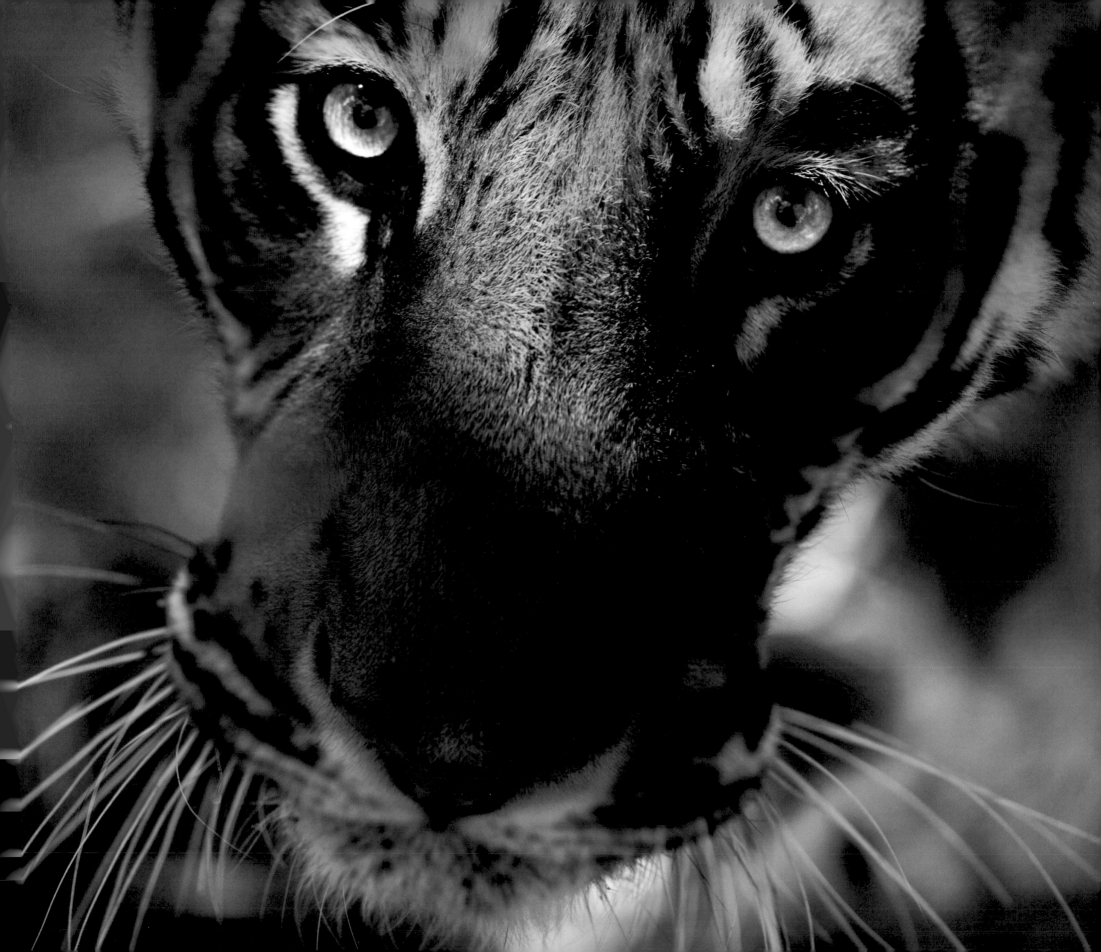

*I think to myself, what a wonderful world.*

GEORGE WEISS AND BOB THIELE

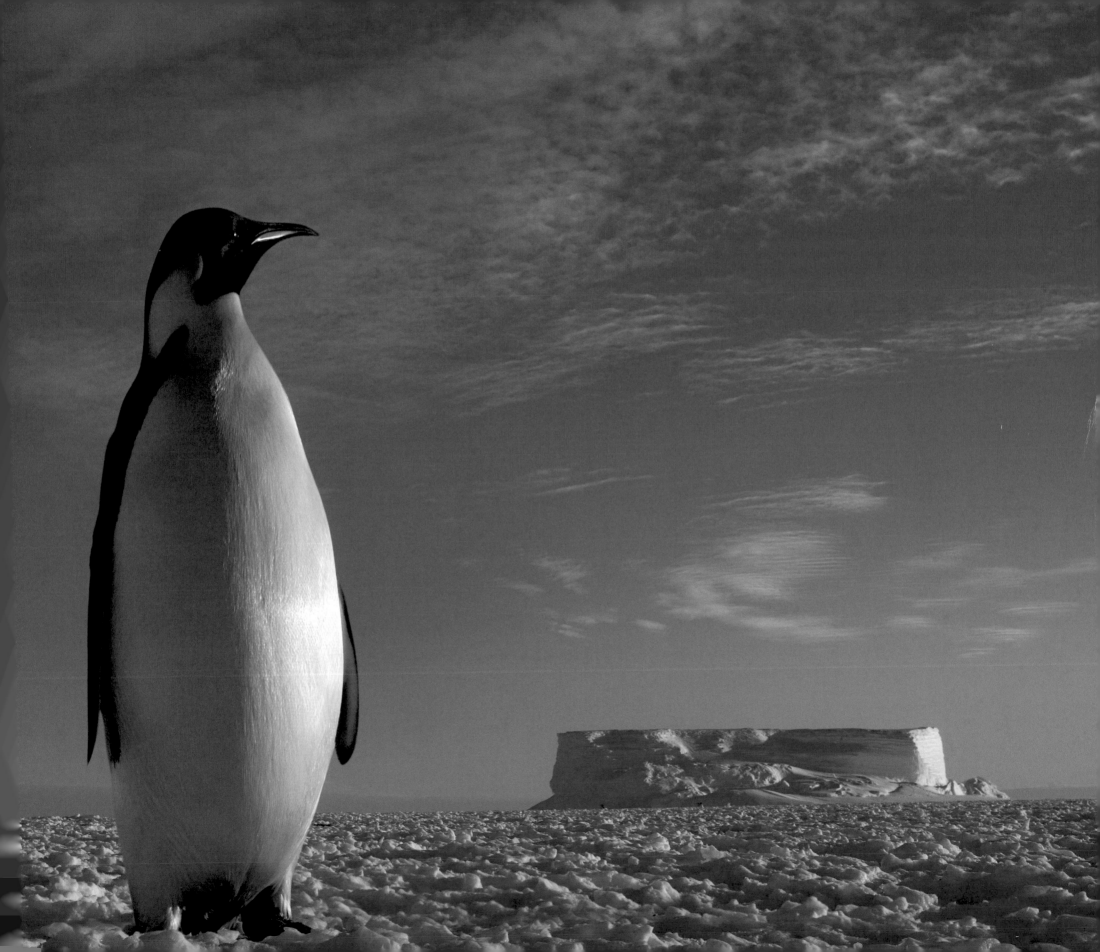

*Walk on, walk on, with hope in your heart,*
*And you'll never walk alone,*
*You'll never walk alone.*

OSCAR HAMMERSTEIN AND RICHARD RODGERS

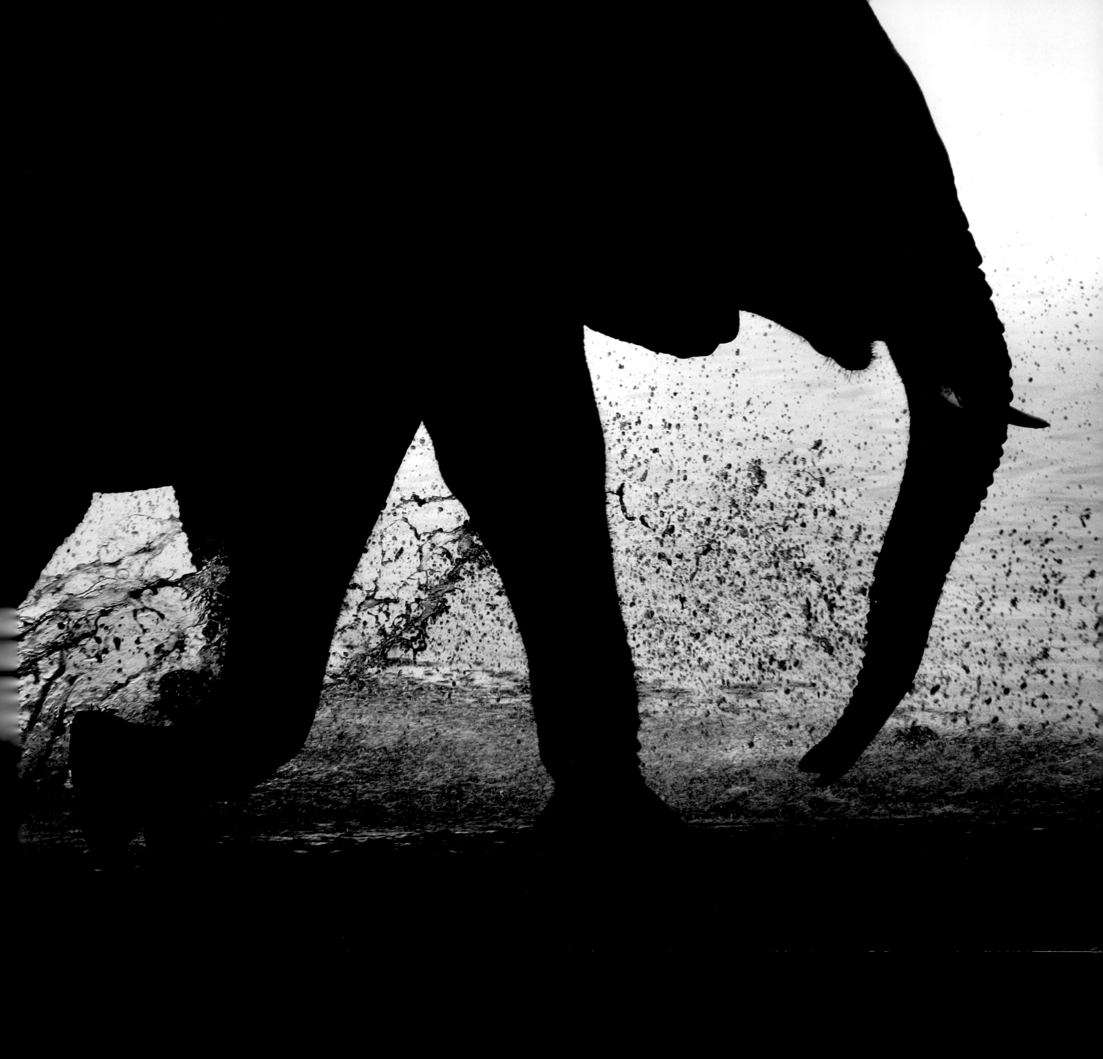

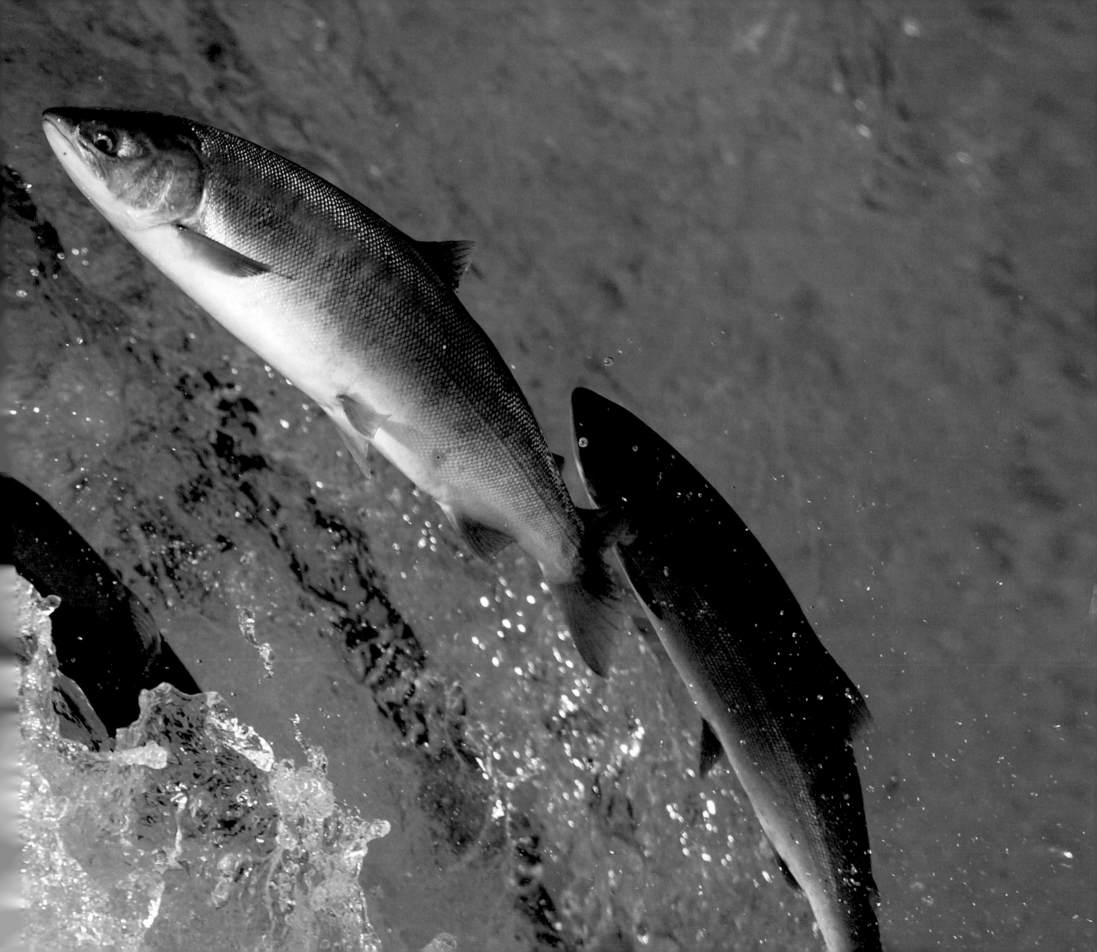

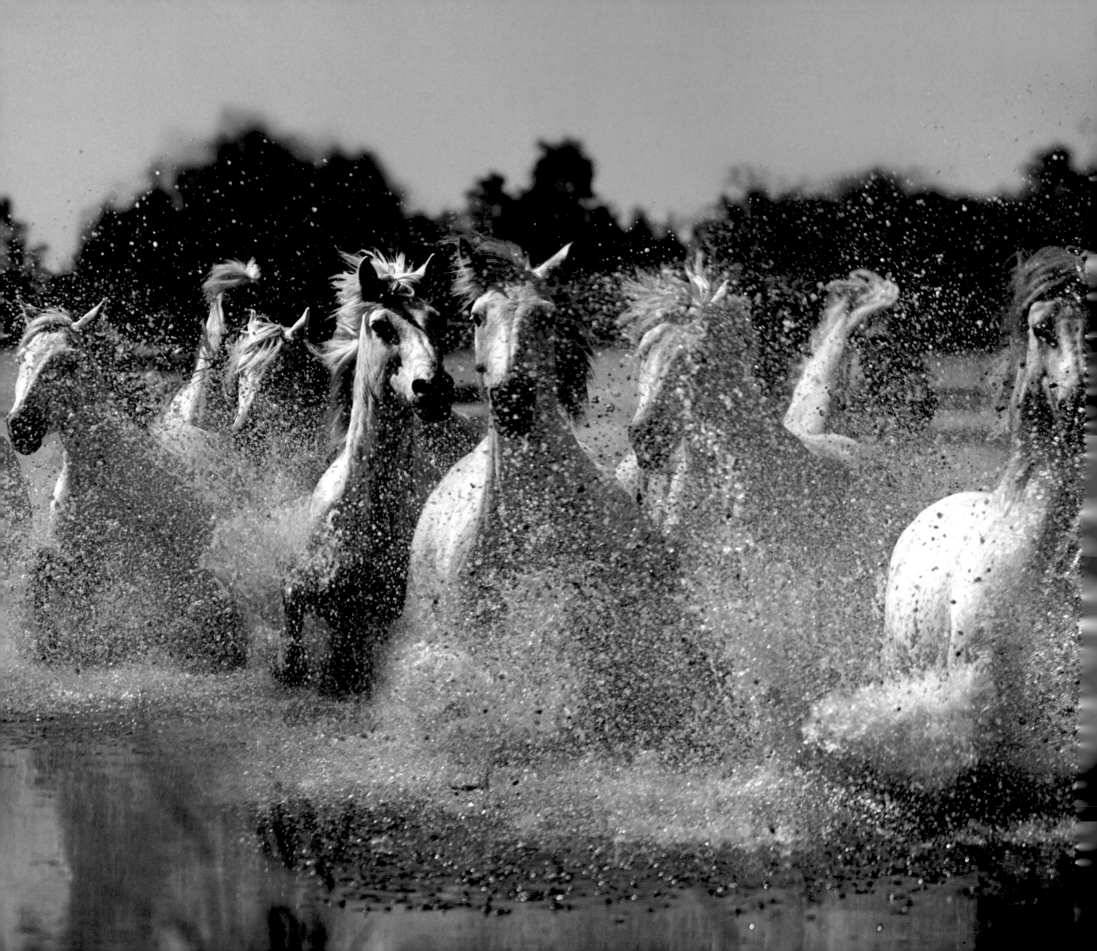

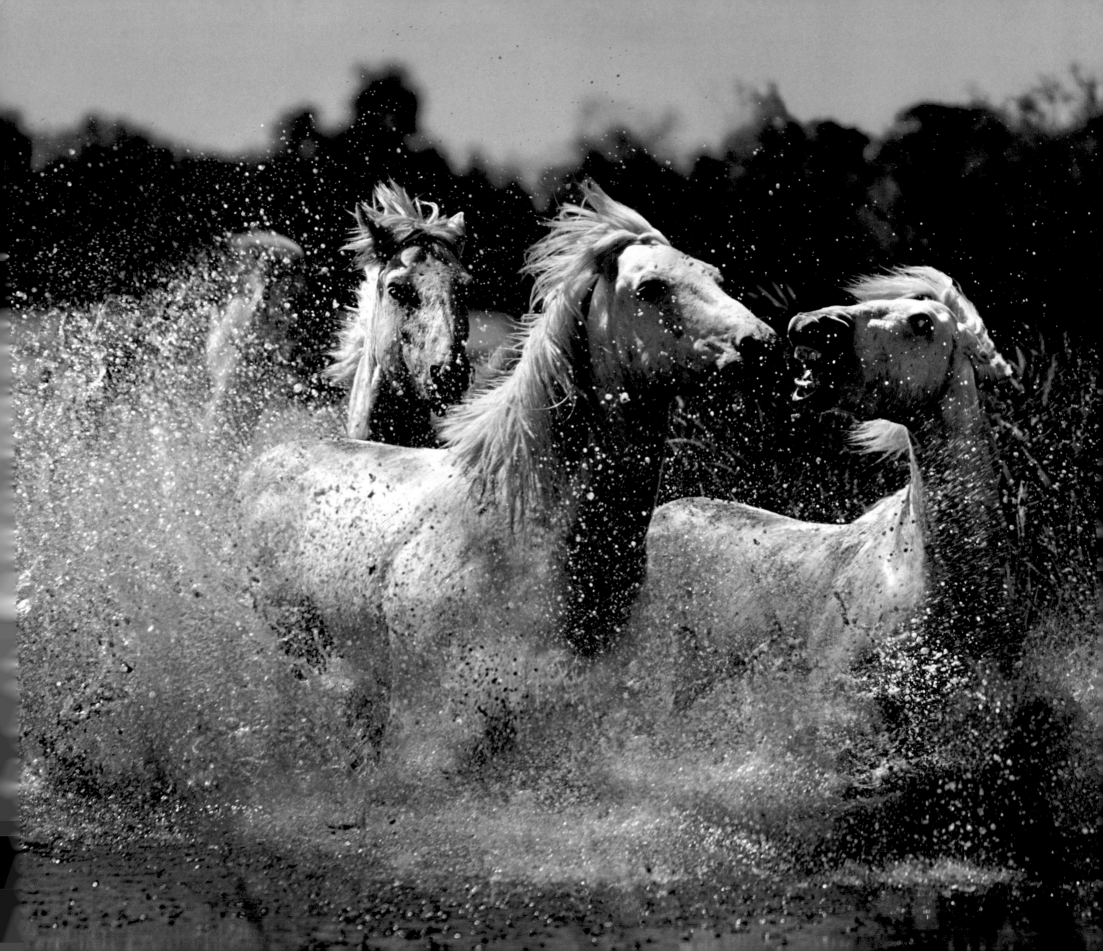

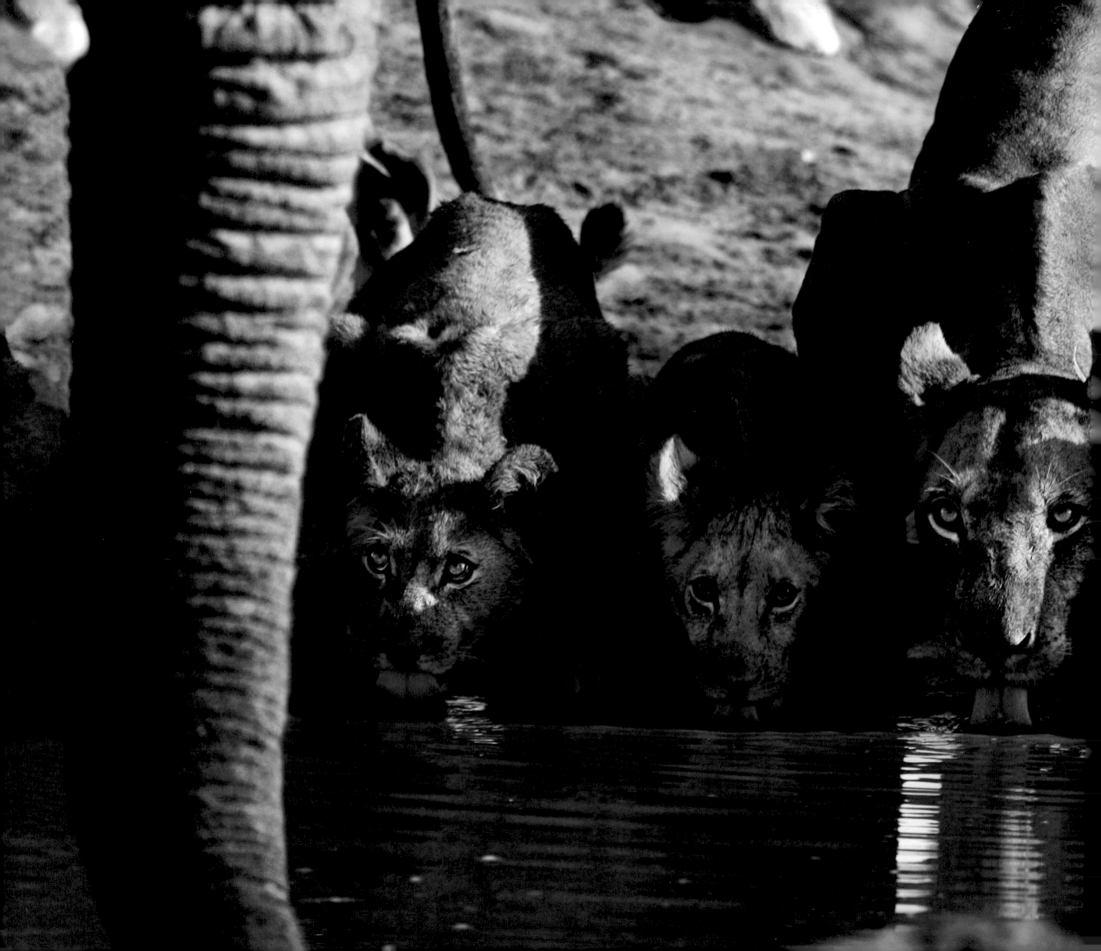

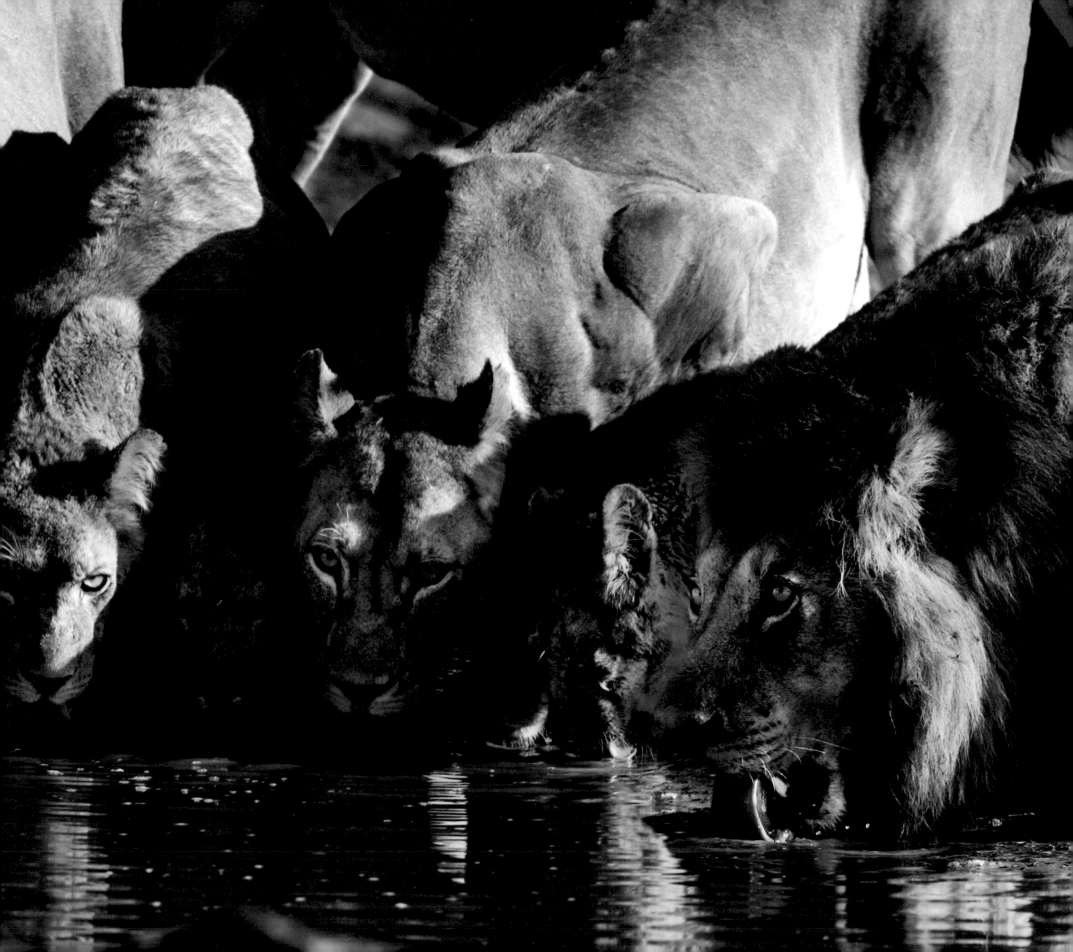

*I had bought two male chimps from a primate colony in Holland. They lived next to each other in separate cages for several months before I used one as a [heart] donor. When we put him to sleep in his cage in preparation for the operation, he chattered and cried incessantly. We attached no significance to this, but it must have made a great impression on his companion, for when we removed the body to the operating room, the other chimp wept bitterly and was inconsolable for days. The incident made a deep impression on me. I vowed never again to experiment with such sensitive creatures.*

CHRISTIAAN BARNARD

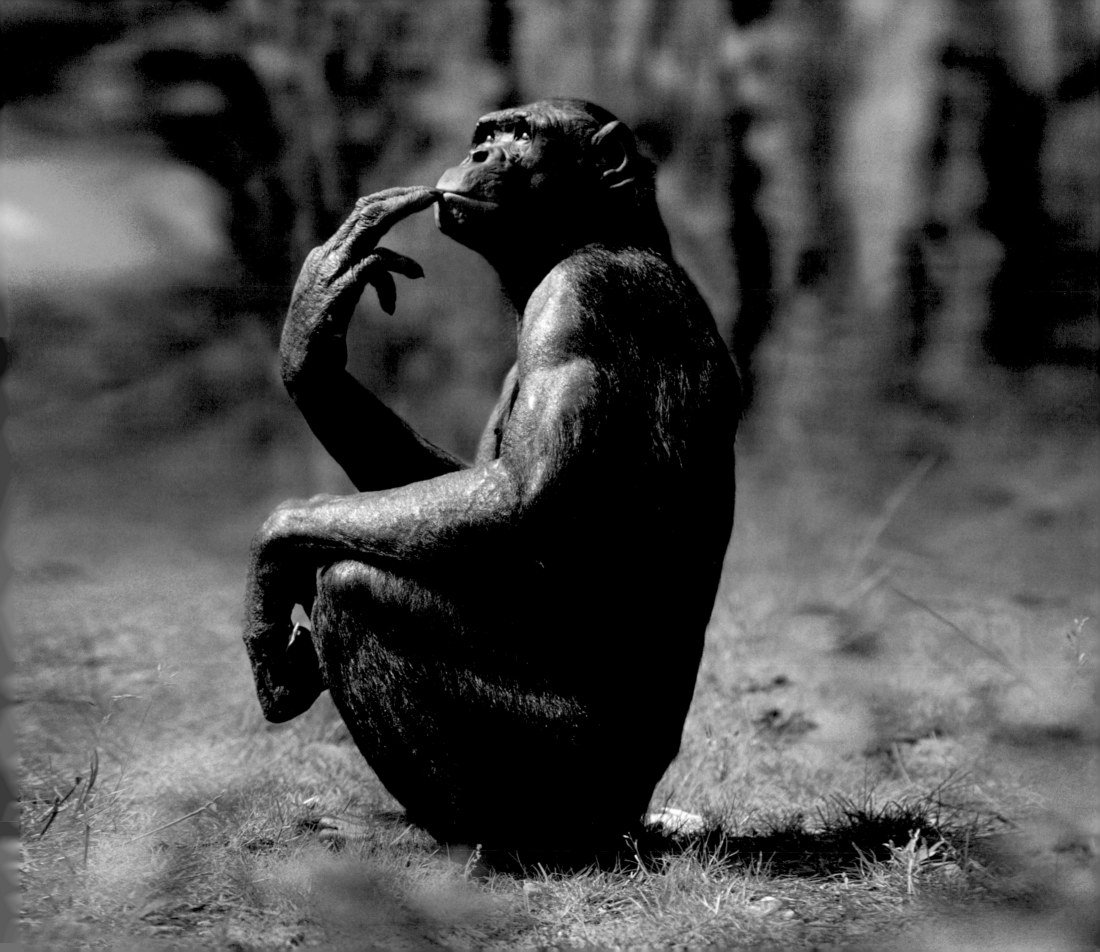

*It is just like man's vanity and impertinence to call*
*an animal dumb because it is dumb to his dull perceptions.*

MARK TWAIN

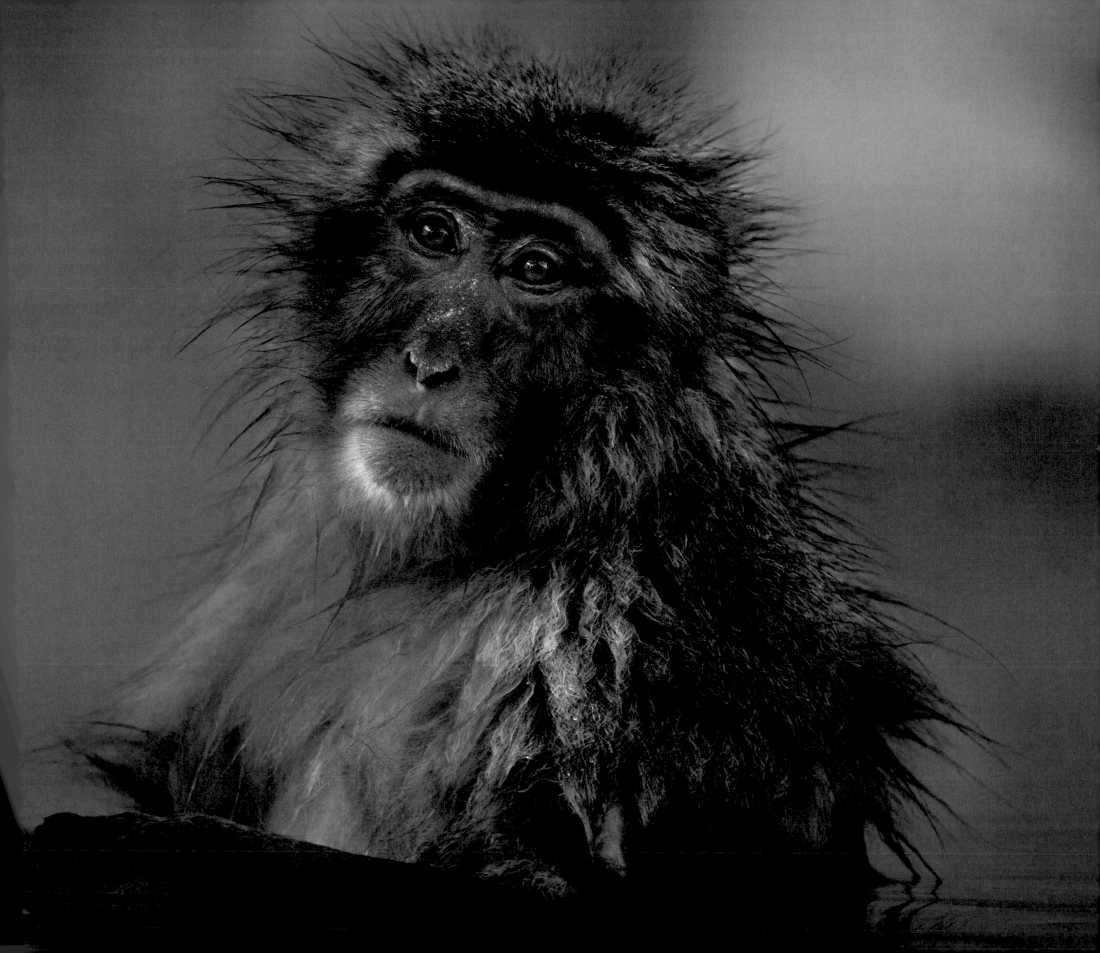

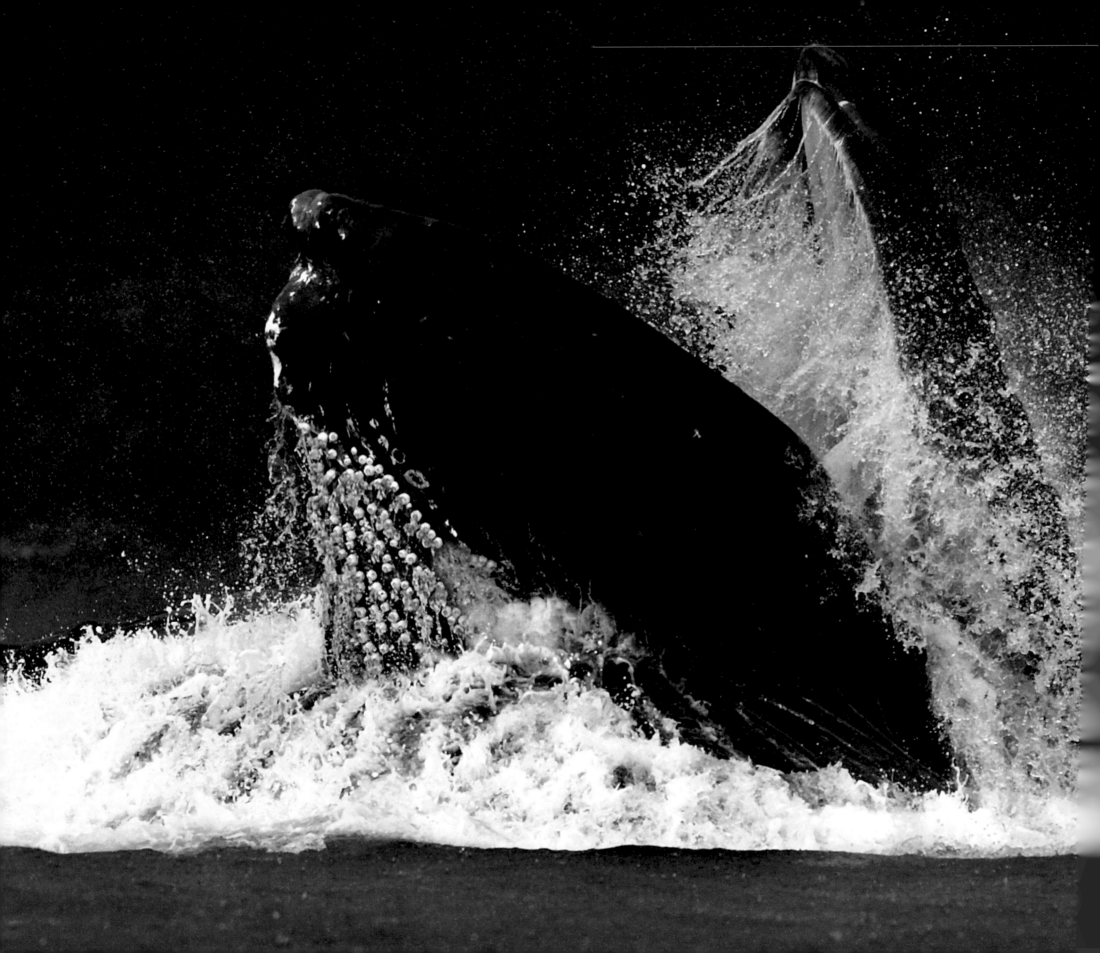

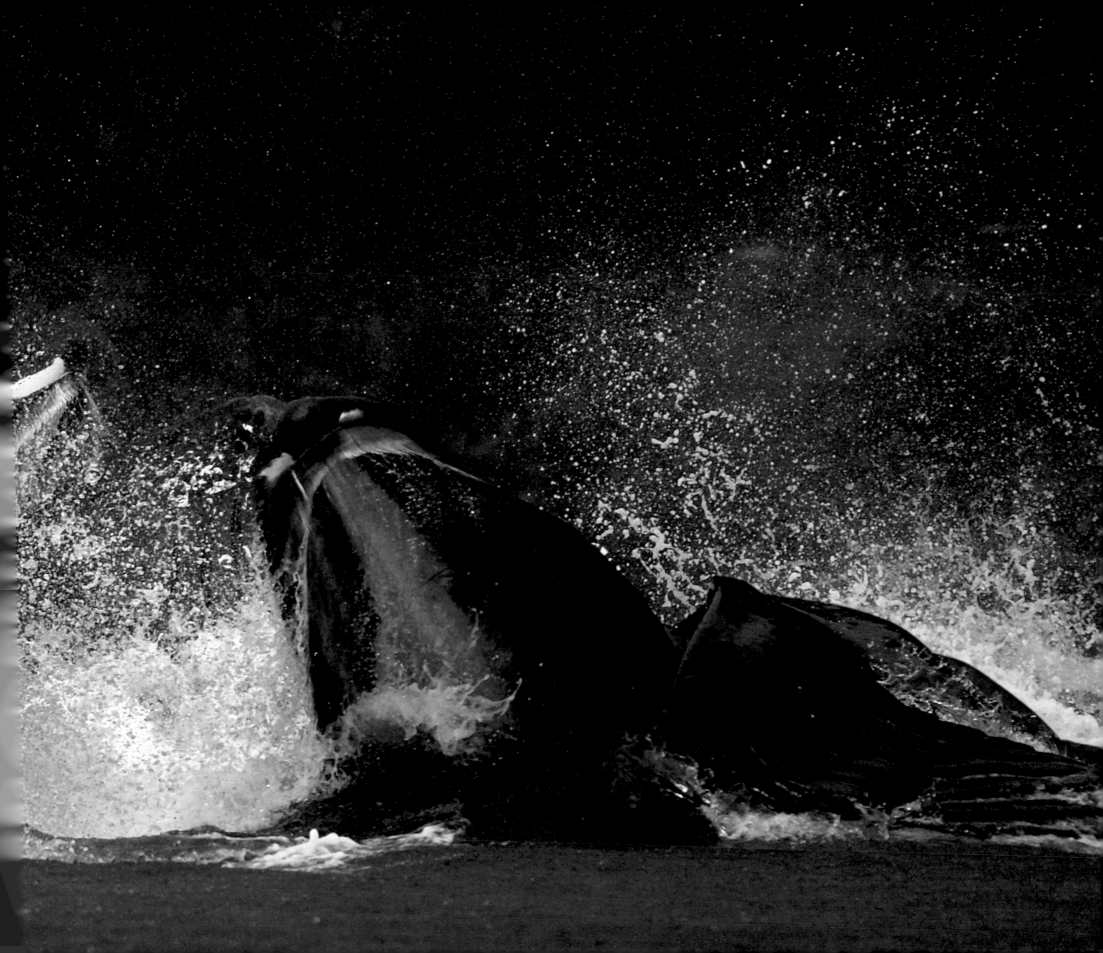

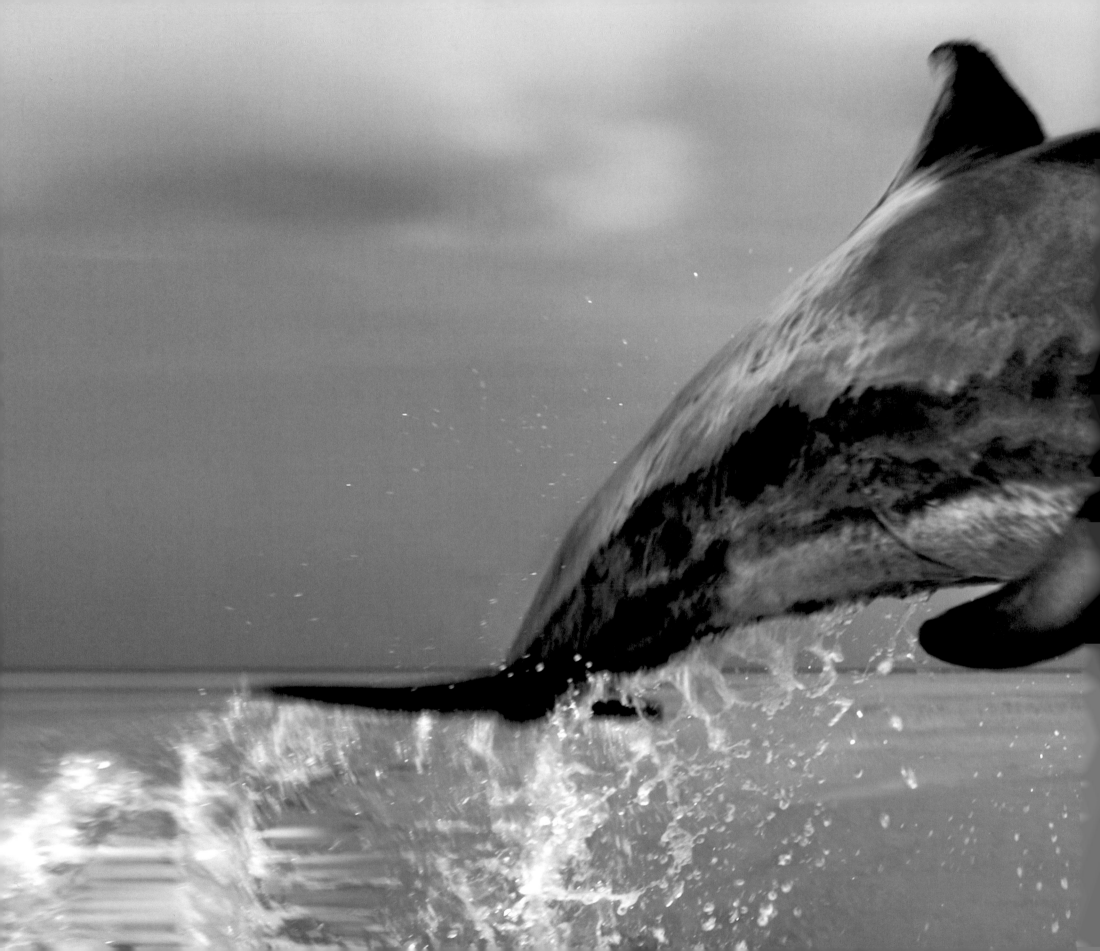

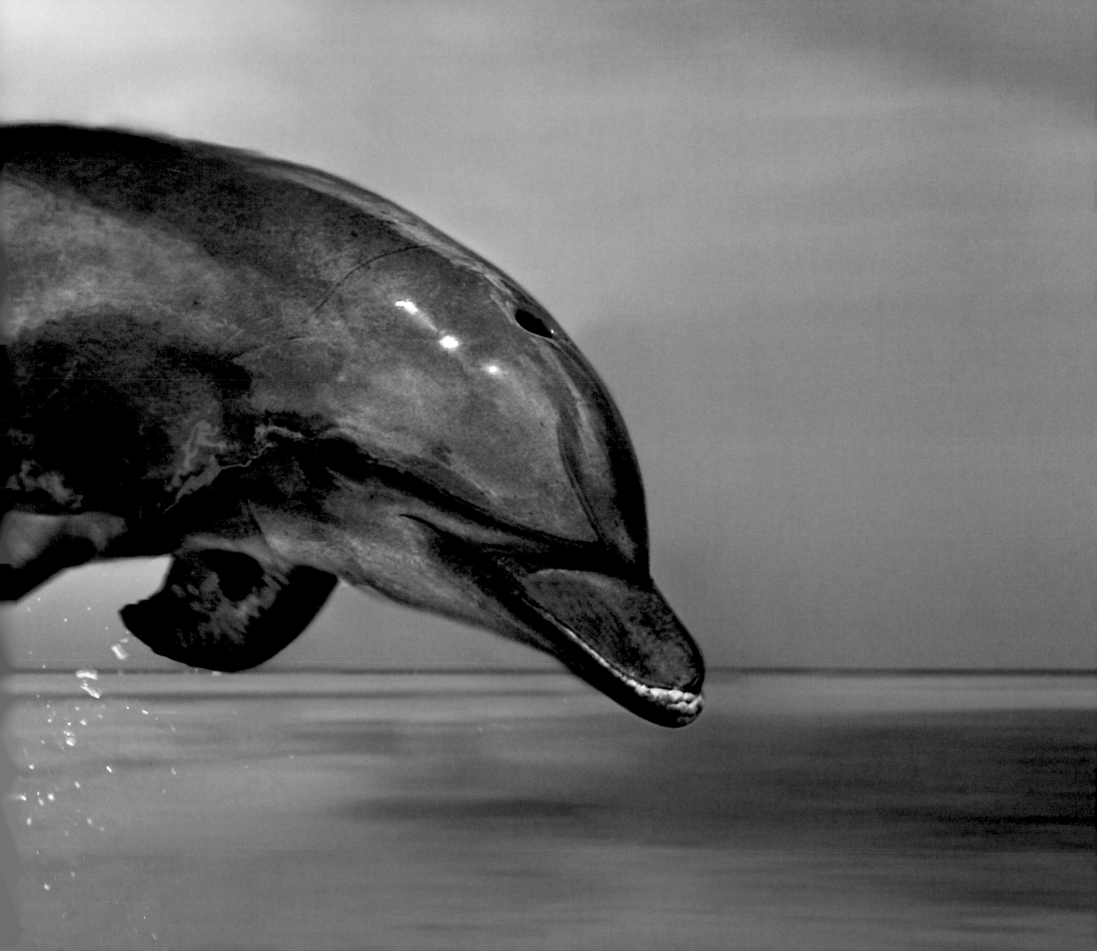

*It is not only fine feathers that make fine birds.*

AESOP

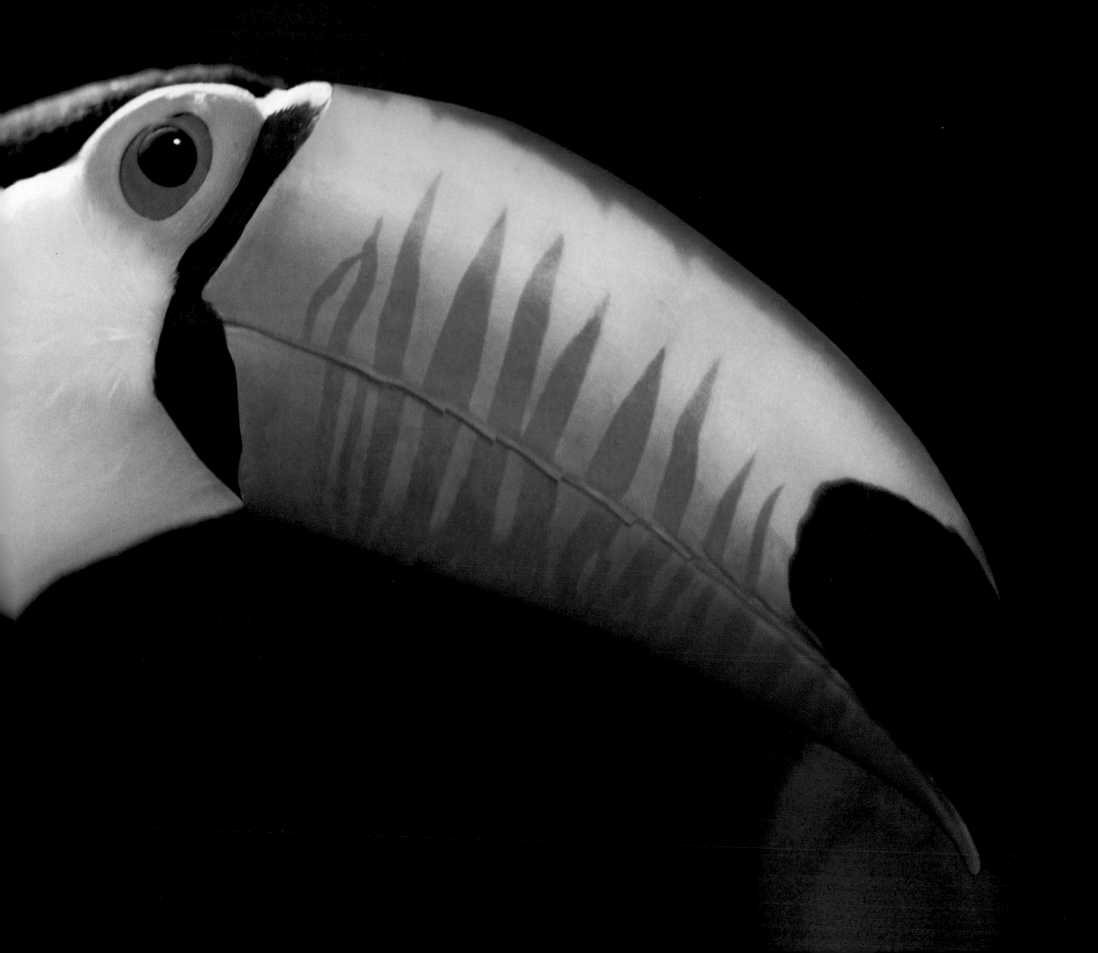

*Birds sing after a storm, why shouldn't we?*

ROSE F. KENNEDY

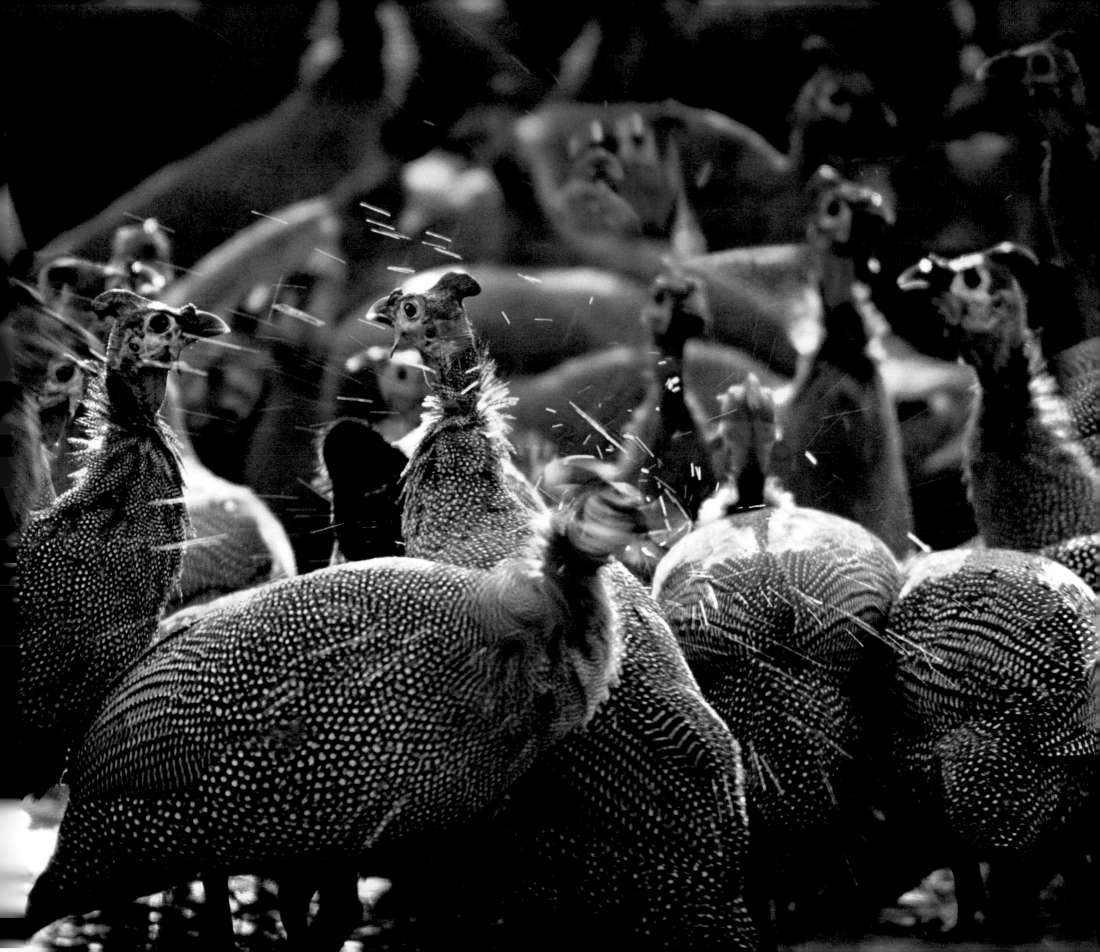

*O lyric Love, half angel and half bird.*
*And all a wonder and a wild desire.*

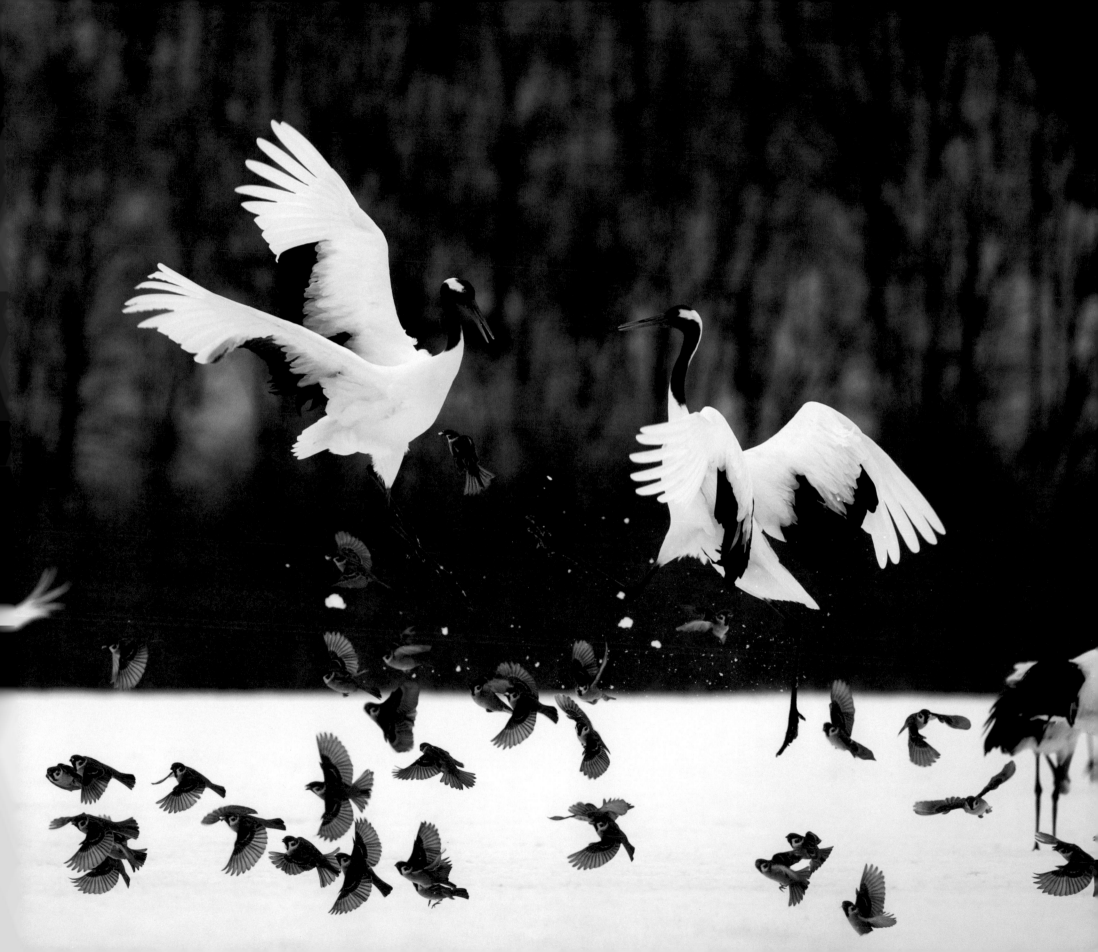

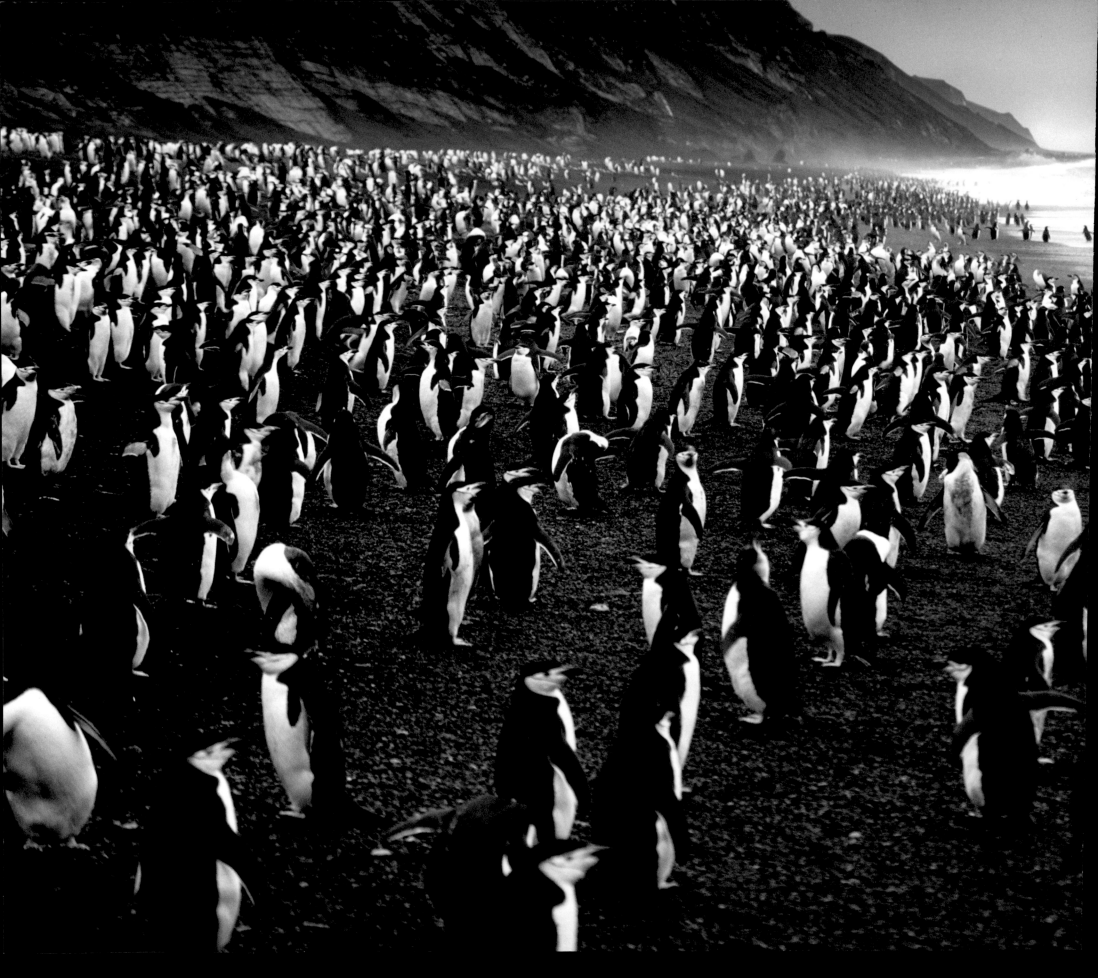

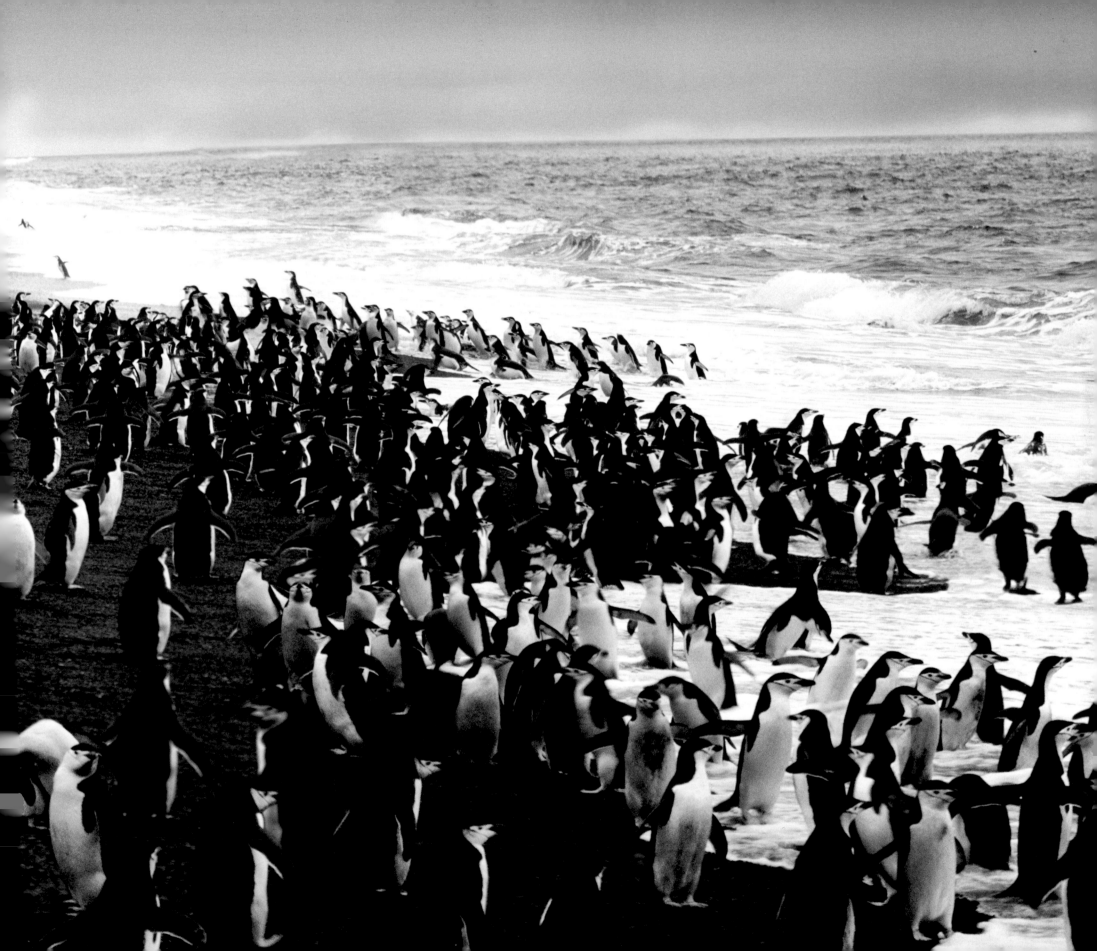

*I hope you love birds too. It is economical.*
*It saves going to heaven.*

EMILY DICKINSON

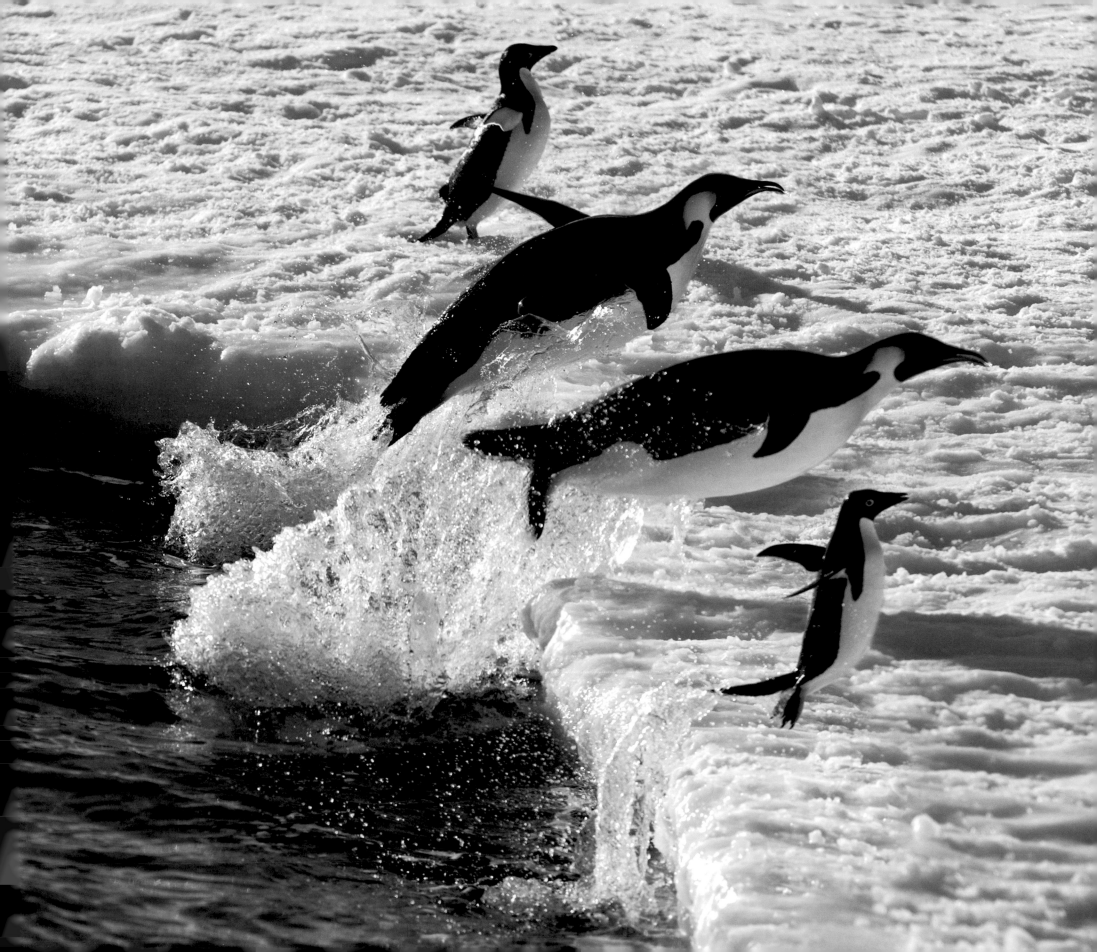

*People must have renounced, it seems to me, all natural intelligence to dare to advance that animals are but animated machines.... It appears to me, besides, that [such people] can never have observed with attention the character of animals, not to have distinguished among them the different voices of need, of suffering, of joy, of pain, of love, of anger, and of all their affections. It would be very strange that they should express so well what they could not feel.*

VOLTAIRE

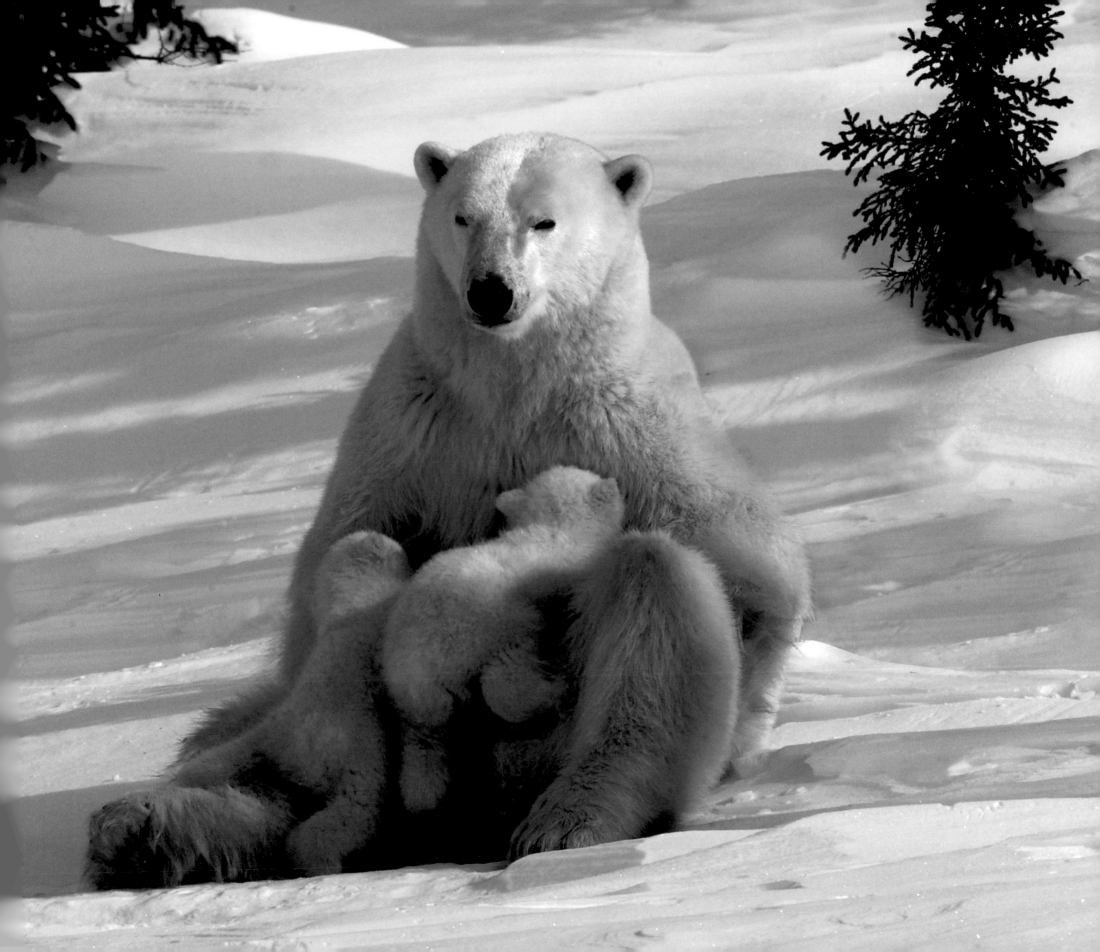

This world is indeed a living being endowed with a soul and intelligence,
a single visible living entity containing all other living entities,
which by their nature are all related.

PLATO

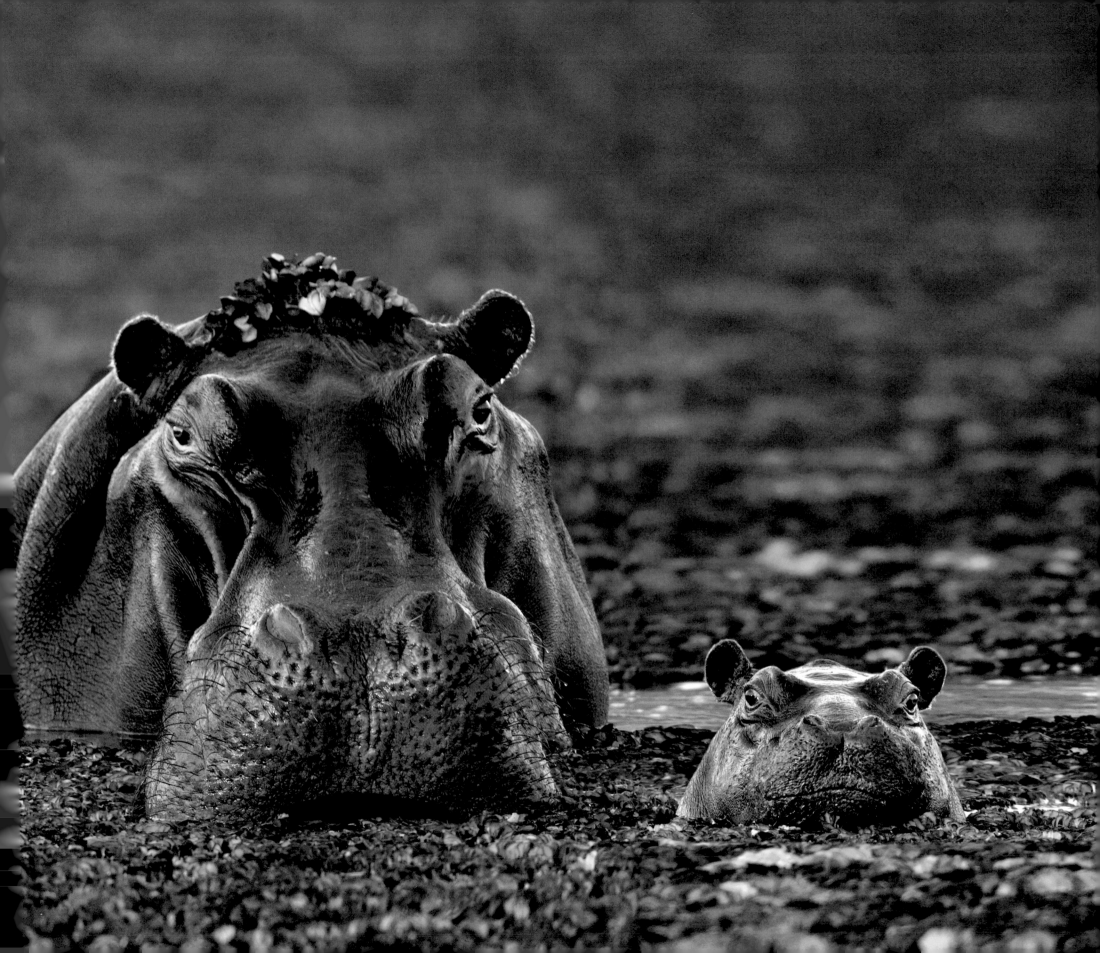

*Until we extend our circle of compassion to all living things,
humanity will not find peace.*

ALBERT SCHWEITZER

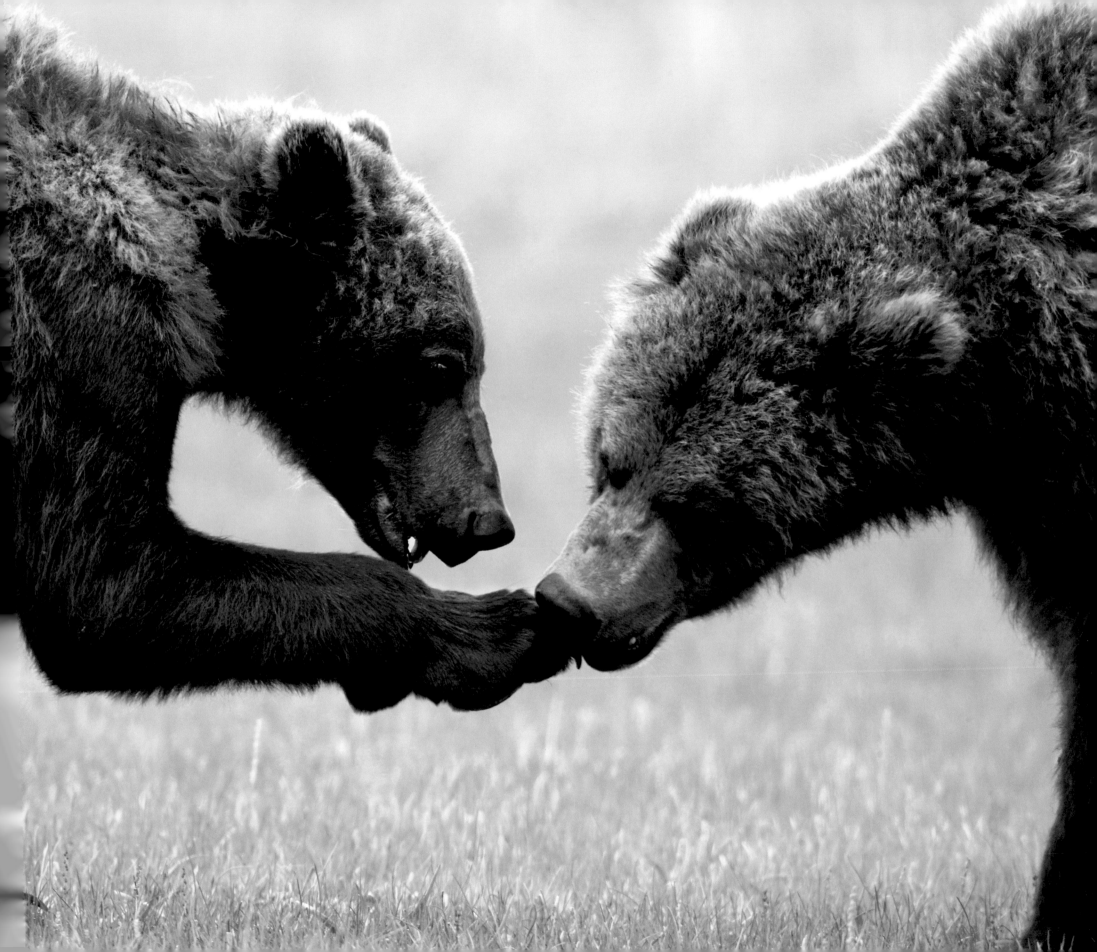

*Teaching a child not to step on a caterpillar*
*is as valuable to the child as it is to the caterpillar.*

BRADLEY MILLAR

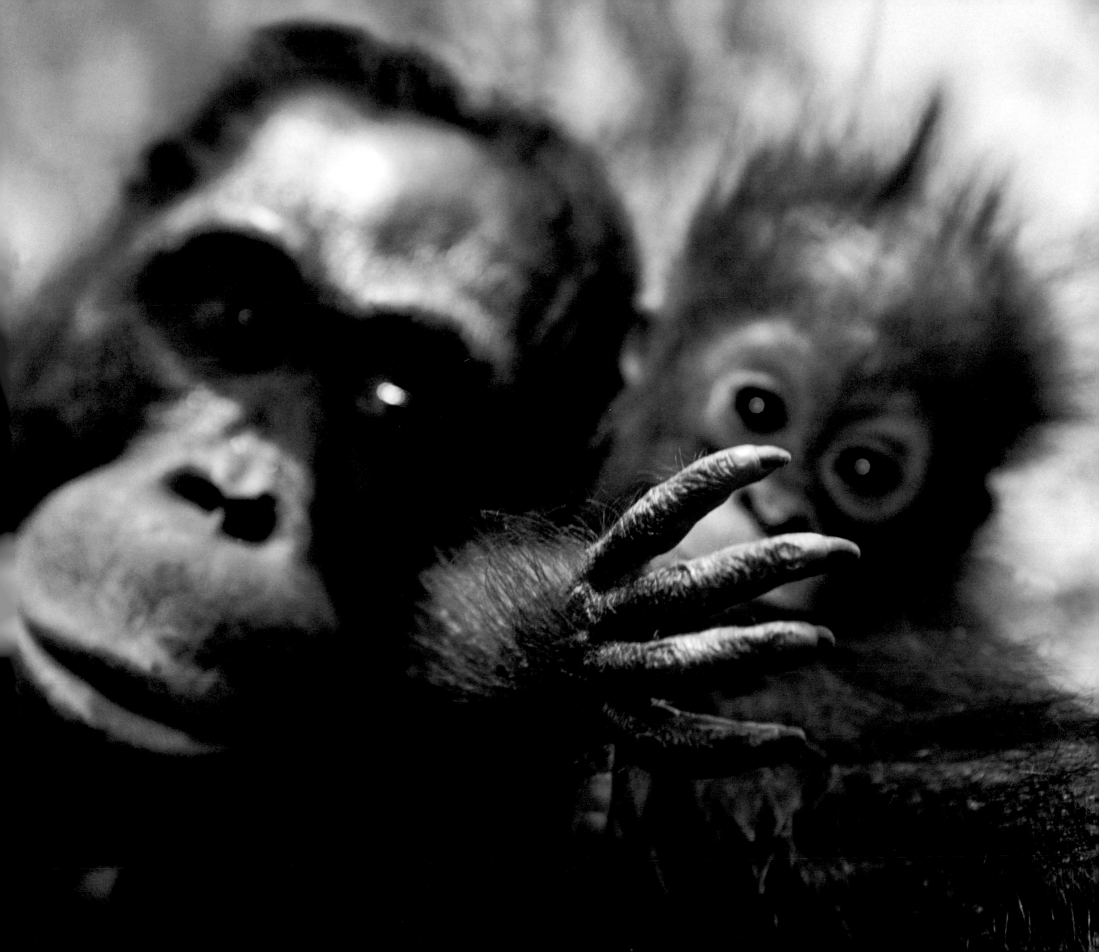

*God made all the creatures and gave them our love and our fear,*
*To give sign, we and they are His children, one family here.*

ROBERT BROWNING

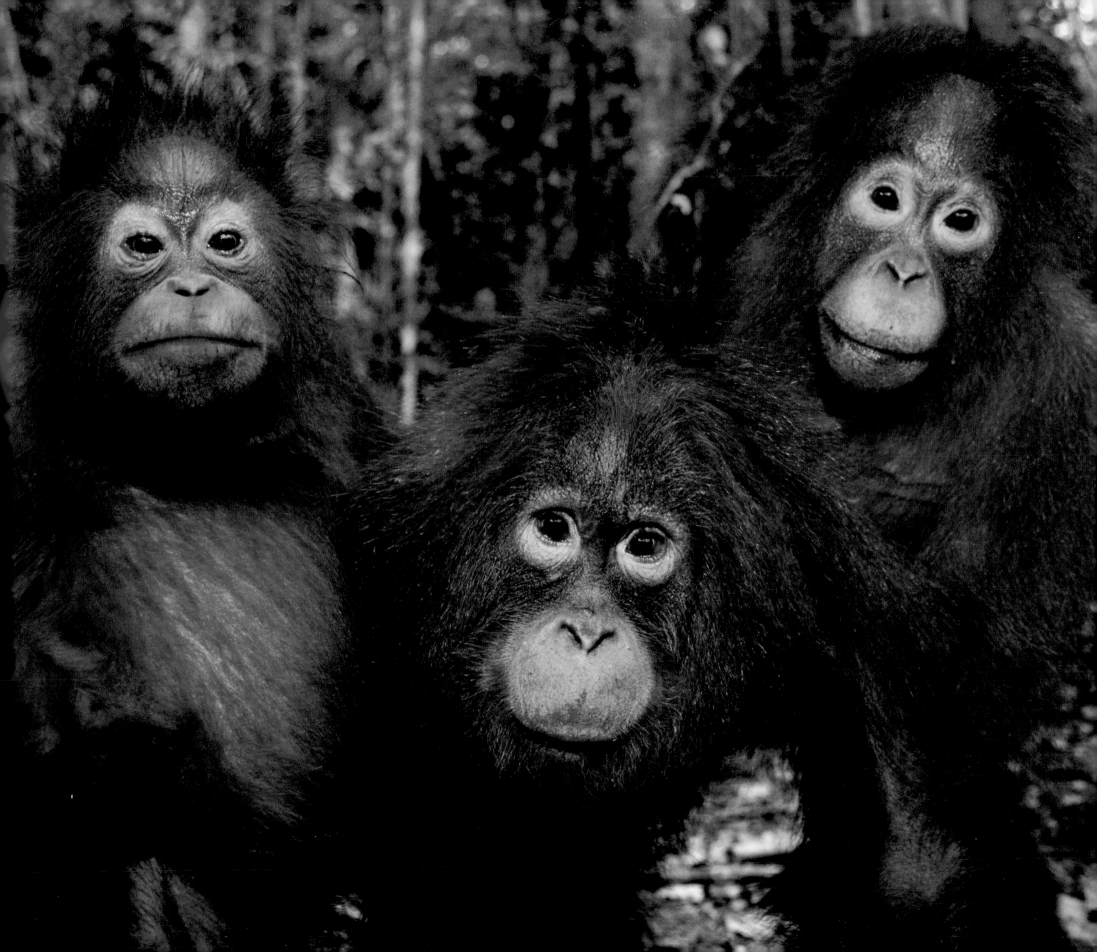

*I know at last what distinguishes man from animals; financial worries.*

ROMAIN ROLLAND

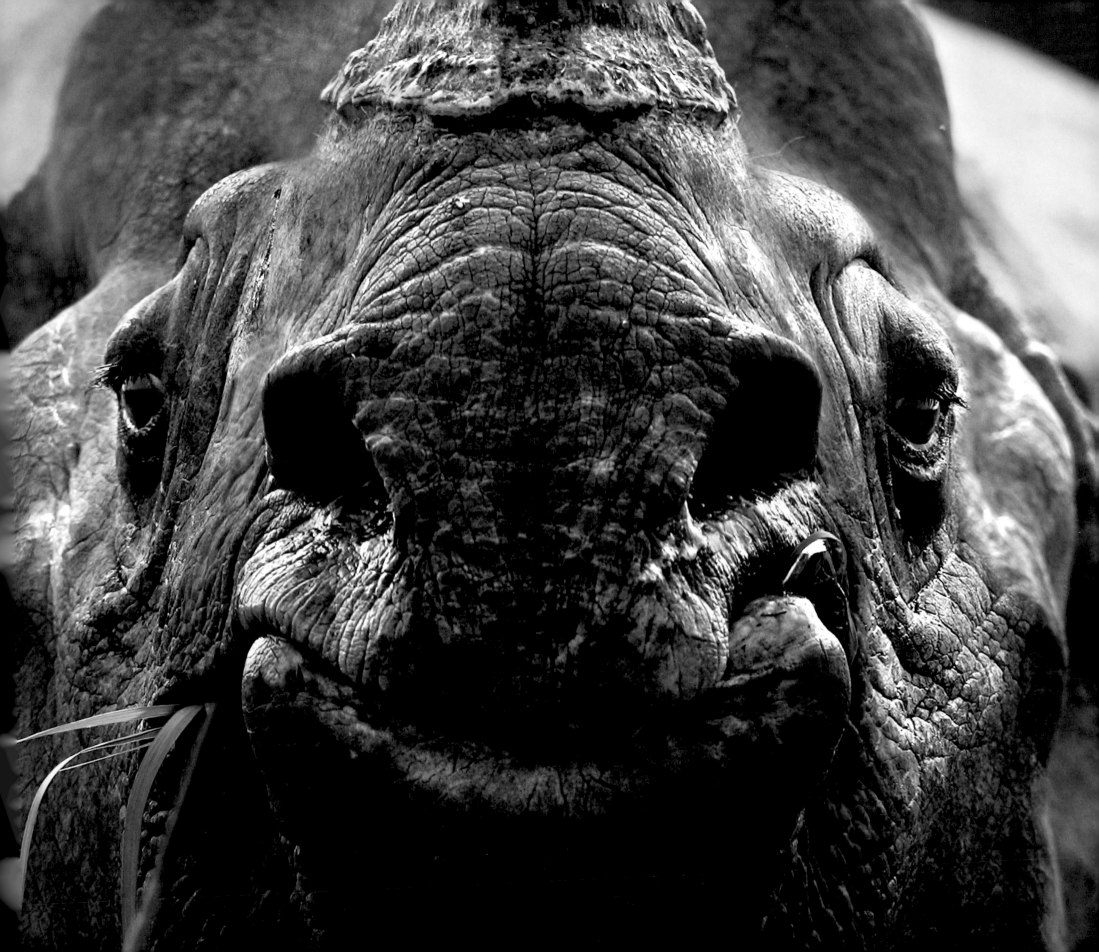

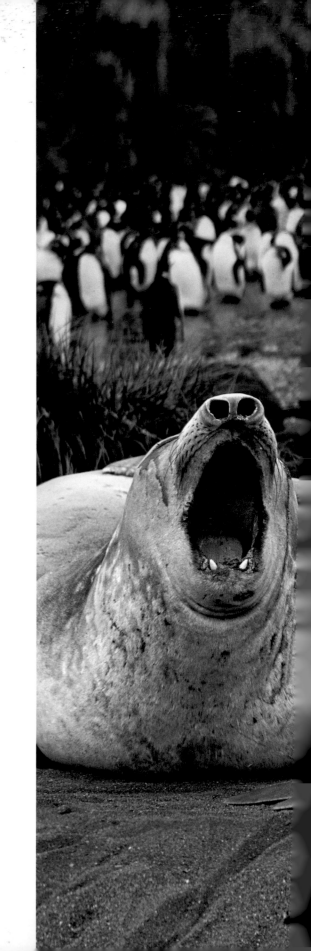

*I ask people why they have deer heads on their walls.*
*They always say because it's such a beautiful animal.*
*I think my mother is attractive, but I have photographs of her.*

ELLEN DEGENERES

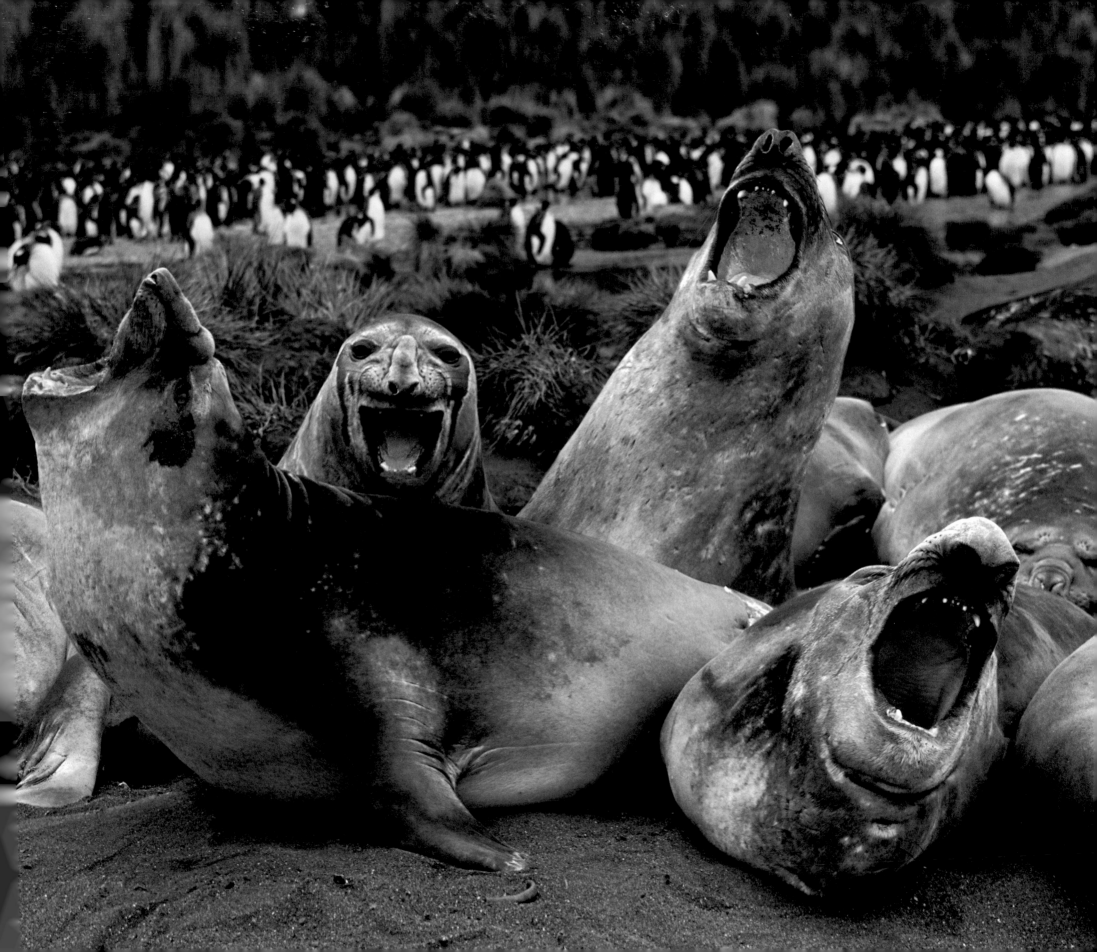

*I realized that if I had to choose,*
*I would rather have birds*
*than airplanes.*

CHARLES LINDBERGH

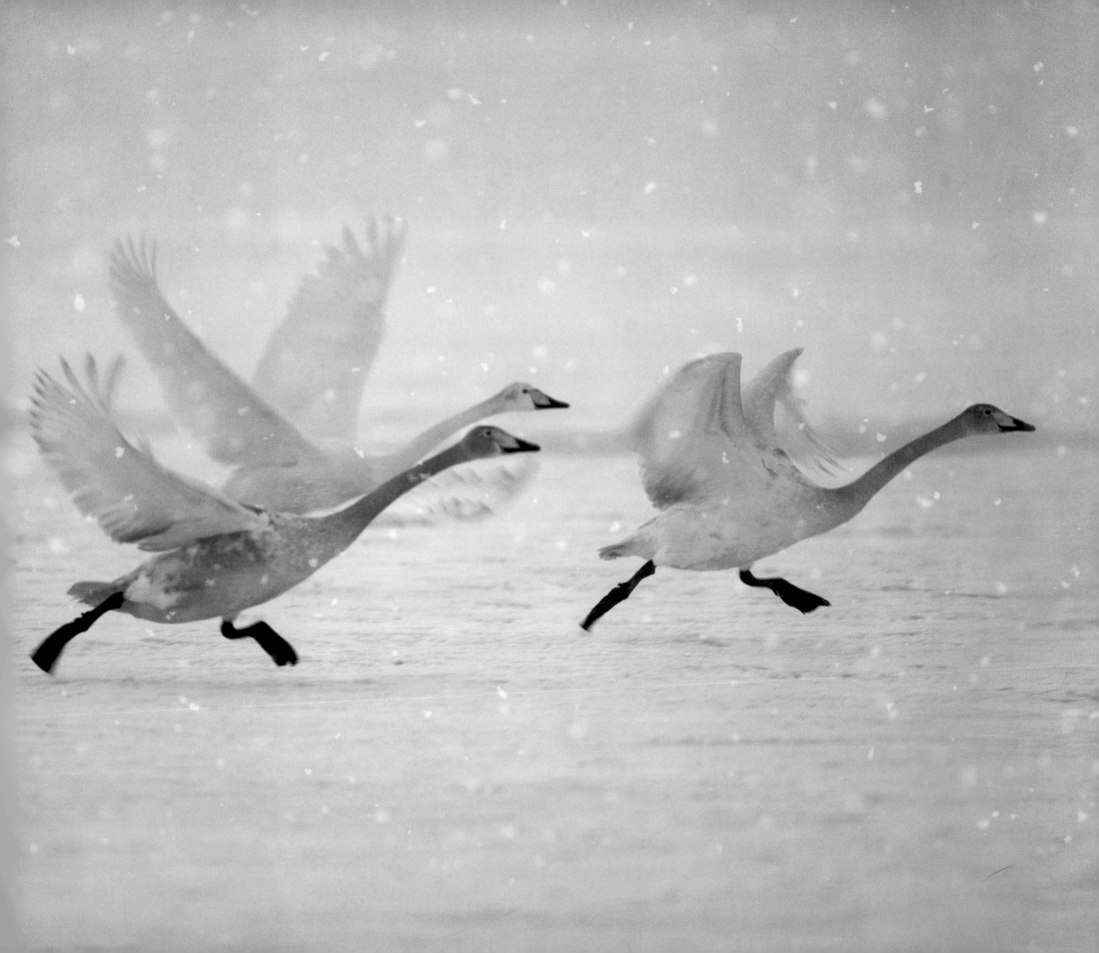

*Only when the last tree has died*
*and the last river been poisoned*
*and the last fish been caught*
*will we realize that we cannot eat money.*

CREE INDIAN PROVERB

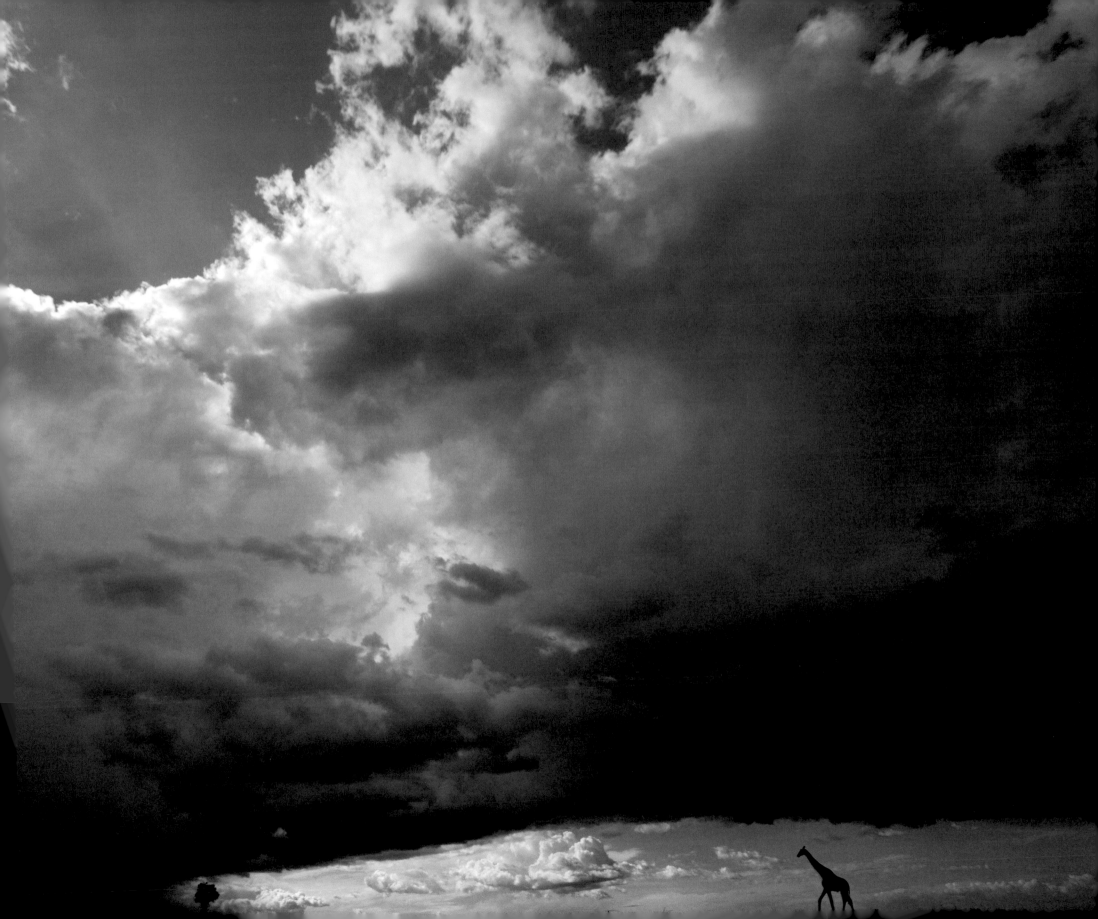

*Is it not possible that the chimpanzees are responding to some feeling like awe? A feeling generated by the mystery of the water; water that seems alive, always rushing past yet never going, always the same yet ever different. Was it perhaps similar feelings of awe that gave rise to the first animistic religions, the worship of the elements and the mysteries of nature over which there was no control? Only when our prehistoric ancestors developed language would it have been possible to discuss such internal feelings and create a shared religion.*

DR JANE GOODALL, DBE

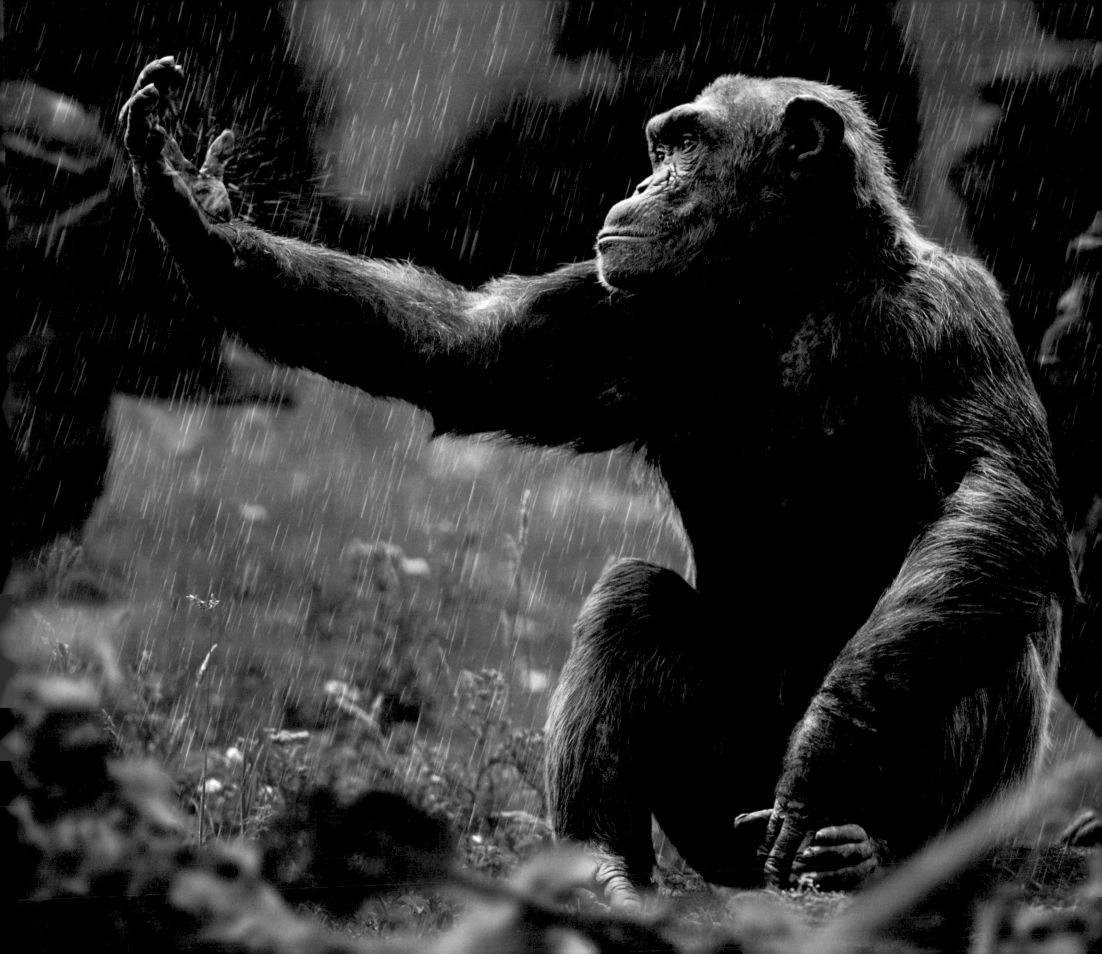

# ABOUT THE PICTURES

**pp. 2–3  Brown bears, Katmai, Alaska**

Gone fishing. The largest gathering in the world of brown bears, also known as grizzly bears, takes place when the sockeye salmon swim upstream to spawn. Normally solitary, these bears wait in the waterfall to catch their prized prey.

**pp. 8–9  Giant panda, China**

Now highly endangered and desperately rare in the wild – fewer than 1,600 remain – a giant panda edges his way down a snowy slope. This protected area is one of the few remaining refuges of this magnificent creature.

**pp. 14–15  Asian elephant, Jaipur, India**

A close-up of the beautiful, knowing eye of an Indian elephant. A powerful national symbol, the elephant is intrinsic to Indian culture and folklore. It has been domesticated and used as a working animal in India for 4,000 years.

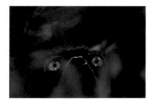

**pp. 16–17  Indri lemur, Madagascar**

The otherworldly eyes of an Indri lemur peer out of vegetation. The largest of the living lemurs, the Indri lives in the tree canopy of eastern Madagascar, where its beautiful song echoes through the mountainous rainforest.

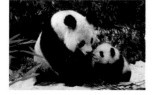

**pp. 18–19  Giant pandas, China**

Panda cubs are dependent on their mother for about two years. Born white and almost completely helpless, they soon develop the distinctive black and white colouring of the adults.

**pp. 20–21  Hippopotamus, Botswana**

Susceptible to sunburn, hippos – their full name means 'river horse' – spend most of their day in water to protect their hairless skin, and forage for food at night when it is cool. They are sociable creatures and live in large groups.

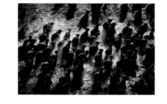

**pp. 22–23  Buffalo, Botswana**

A large herd of African buffalo run through grassy swampland in the Okavango delta. Buffalo herds have no single leader, but the animal who knows a particular area best takes control at that time.

**pp. 24–25  Camargue horse, France**

In a blur of movement, a Camargue horse streaks through water. These tough, spirited horses thrive in the harsh climate of the Camargue, which is either scorchingly hot, or whipped by icy winds blowing from the Alps.

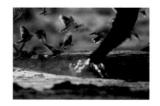

**pp. 26–27  Elephant and doves, Botswana**

Cape turtle doves are disturbed by an elephant at the waterhole. Common throughout southern Africa, in arid regions these birds often flock in large numbers where water can be found.

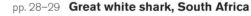

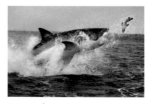

**pp. 28–29  Great white shark, South Africa**

A great white shark, hunting fur seals, shows its awesome power as it launches itself out of the water and tosses its prey into the air. Contrary to popular belief, few humans are killed by great whites.

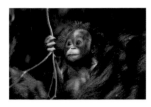

### pp. 30–31 Orang-utans, Borneo

Maternal love and protection is as clear in the animal world as in human society. Here an orang-utan sits with his mother. The orang-utan is the world's largest tree-dwelling animal, even giving birth in the forest canopy.

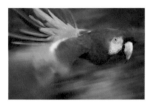

### pp. 32–33 Scarlet macaw, Peru

A magnificent wild scarlet macaw swoops in flight, a blur of wings. The largest of the parrots and endangered, their brilliantly coloured plumage helps them locate each other in the rainforest. Noisy, sociable birds, they live in flocks and pair for life.

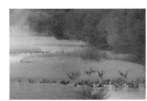

### pp. 34–35 Red-crowned cranes, Japan

In a snow-covered marsh lit by early morning sunlight, Japanese cranes gather to feed. Conservation efforts have improved numbers in the wild, which were critically small in the 1920s. They mate for life after an entrancing courtship display.

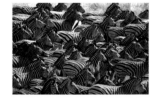

### pp. 36–37 Zebras, Okavango, Botswana

Zebras sweep through lush grassland. Slower than horses over short distances, they have far greater stamina and endurance. Their free spirit has meant humans have not succeeded in domesticating them.

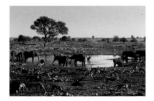

### pp. 38–39 African elephants, Namibia

A large group of African elephants spread out along the rim of a waterhole. This herd has many cows, with calves and sub-adults. After they drink, the elephants bathe in cool mud or roll in dust to protect their skin.

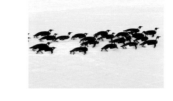

### pp. 40–41 Emperor penguins, Antarctica

Emperor penguins toboggan across the stark, frozen Antarctic landscape. Breeding colonies can be a considerable distance from the open sea, and this form of motion speeds up their progress.

### pp. 42–43 Zebras, Okavango, Botswana

A herd of zebra, photographed from the air, streams across watery grassland. Each zebra has stunning, individually patterned black and white stripes. Taken as a whole, the herd's stripes make it difficult for predators to target one animal.

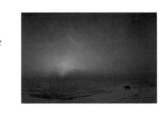

### pp. 44–45 Polar bear, Canada

Alone in a spectacular sunset, a polar bear, the world's largest land carnivore, traverses an icy landscape near Cape Churchill. Thick, warm, waterproof fur helps polar bears to survive extreme conditions. Seals are their main food, hunted on ice.

### pp. 46–47 Wildebeest, Kenya

Wildebeest are found in vast herds in parts of Kenya and Tanzania. Streaming across the Mara River, they follow the rainfall across the east African plains to new grazing areas during the seasonal Great Migration.

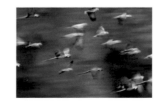

### pp. 48–49 Macaws and parrots, Peru

A mixed flock of scarlet and blue–yellow macaws, accompanied by green parrots, sweep across the sky in a colourful display. Keeping parrots as pets fuels illegal trafficking, which has severely affected numbers in the wild.

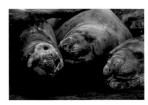 **pp. 50–51  Elephant seals, Antarctica**

A pod of elephant seals lounge comfortably together in easy companionship. Awkward and clumsy on land, in the sea they are powerful swimmers. Pups are reared in large colonies on suitable beaches.

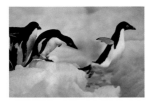 **pp. 52–53  Adélie penguins, Antarctica**

Flippers held wide, an Adélie penguin jumps into the freezing water. Adélies have a white ring around the eye, and a short beak partly covered in feathers. They fish in groups, returning to the mainland to feed their chicks.

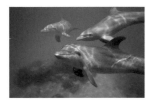 **pp. 54–55  Bottlenose dolphins, Honduras**

Dolphins, curious and friendly by nature, swim in a close family group. Renowned for their intelligence, dolphins are frequently kept in captivity, though research has shown that this leads to a shorter life expectancy.

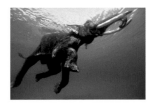 **pp. 56–57  Asian elephant, Andaman Islands**

Swimming enthusiastically in the clear blue waters of the Andaman Sea, this large bull elephant is an unusual and somewhat incongruous sight. He probably learned to swim when young in order to cross between islands.

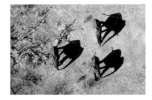 **pp. 58–59  African elephants, Botswana**

An aerial view captures the shadows of three elephants as they move across the parched, dusty plain. Blood vessels at the back of the African elephant's large ears expel heat and cool the animals.

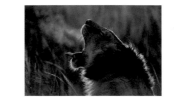 **pp. 60–61  Lion, Masai Mara, Kenya**

A yawning lion silhouetted against sunlit grasses. Male lions, alone among the big cats, have manes. These are primarily for show, making them appear larger and more aggressive.

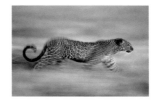 **pp. 62–63  Leopard, Masai Mara, Kenya**

A leopard walks languidly through grassland. Masters of camouflage, leopards are effective at stalking prey. They are good climbers, and are able to drag kills heavier than themselves up trees, out of the reach of scavengers.

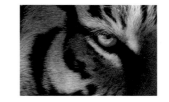 **pp. 64–65** (and front cover)  **Siberian tiger, China**

The eye of the tiger: hunted almost to extinction, a Siberian tiger surveys his diminishing world. Largest of all the big cats, some Siberian tigers are still found in remote areas of Russia and China.

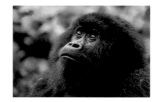 **pp. 66–67  Mountain gorilla, Uganda**

The thoughtful gaze of this female mountain gorilla is testament to the huge intelligence of these wonderful creatures. They are one of our closest genetic relatives and are critically endangered.

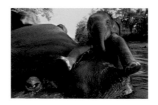 **pp. 68–69  Asian elephants, Kanha, India**

A young elephant playfully climbs over his mother as they bathe in a river. Asian elephants are smaller than the African species, but are still the largest land mammals in Asia.

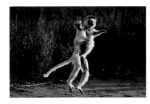

pp. 70–71 **Verreaux's sifaka, Madagascar**

Taking a ride: a bright-eyed baby sifaka clings to his mother as she hops along in the sunlight. Sifakas are superbly adapted, able to leap from tree to tree using well-developed leg muscles, or to hop upright on the ground.

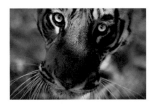

p. 73 **Bengal tiger, Bandhavgarh, India**

Photographed from the back of an elephant, a beautiful tiger is startled out of her sleep. Once widespread in India's jungles, hunting and destruction of habitat has left only a few Bengal tigers in the wild.

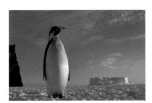

pp. 74–75 **Emperor penguin, Antarctica**

An Emperor penguin stands sentinel in the white wilderness of Antarctica. Emperors are unusual among penguins for living and breeding on sea ice, rather than on land.

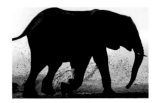

pp. 76–77 **African elephant, Botswana**

An elephant splashes along the margins of a river. Elephants have been hunted for their ivory since prehistoric times, but poaching in the last century has decimated wild elephant populations.

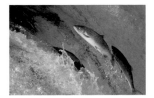

pp. 78–79 **Sockeye salmon, Alaska**

Sockeye salmon struggle upstream in the cold rivers of Alaska. Each year millions of salmon make this hazardous journey from the sea to freshwater spawning grounds, returning to the lake or stream where they hatched.

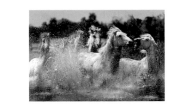

pp. 80–81 **Camargue horses, France**

Crashing through water, these Camargue horses, indigenous to the salty marshlands of the Rhône Delta in southern France since prehistoric times, are descendants of glacial wild horses crossed with Arabians.

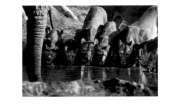

pp. 82–83 **Lions and elephant, Botswana**

Wary eyes on the elephant, a lion family drinks at a waterhole. Given a chance, lions will attack and kill young, vulnerable calves, but they keep a respectful distance from adults in their prime.

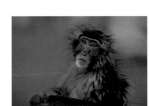

p. 85 **Bonobo, Apenheul, Netherlands**

More similar in appearance to humans than any other ape, bonobos are found in the wild only in central Africa. Their very survival is threatened by indiscriminate killing for the 'bushmeat' trade.

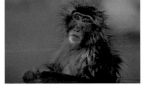

pp. 86–87 **Japanese macaque, Japan**

A Japanese macaque sits in a natural hot spring, gazing through the rising steam. Also known as snow monkeys, they are found further north than any other primates, and are capable of surviving bitterly cold winters.

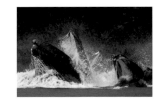

pp. 88–89 **Humpback whales, Alaska**

Several humpback whales breach the icy waters of St Peter Sound. Working in harmony, they encircle a school of fish with air bubbles, before lunging to the surface with mouths wide open to capture their prey.

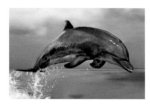

**pp. 90–91 Bottlenose dolphin, Honduras**

A bottlenose dolphin skims over the water at breathtaking speed. There is less friction in air than water, so dolphins move faster by alternating between the two. This is also known as 'porpoising'.

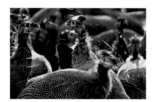

**pp. 92–93 Toco Toucan**

Among the noisiest of the birds that populate the dense South American rainforests, toucans are also instantly recognizable by their oversized, brightly-coloured beaks. The Toco has the largest bill of all the toucans.

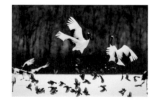

**pp. 94–95 Helmeted guinea-fowl, Botswana**

Early morning light sparkles off droplets as a flock of blue–grey speckled guinea-fowl refresh themselves at a waterhole. Capable of flight, but preferring to walk or run, large groups of these noisy birds roost together in trees at night.

**pp. 96–97 Red-crowned cranes, Japan**

Seemingly oblivious to the noisy flock of bulbuls, these tall, elegant cranes perform their intricate courtship ballet. In Japan they are considered to be a symbol of longevity and peace.

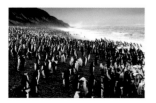

**pp. 98–99 Chinstrap penguins, Antarctica**

On a cold, windswept beach, battered by the Southern ocean, a vast breeding colony of chinstrap penguins stretches into the distance. Small but hardy, these feisty birds defend their territory and are aggressive towards intruders.

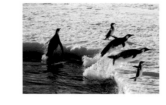

**pp.100–101 Penguins, Antarctica**

A mixed group of Emperor and Adélie penguins burst up out of the ocean, and onto a shelf of ice. Though flightless, penguins move with great speed and agility in water, building up momentum which can propel them high into the air.

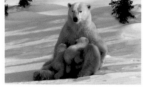

**pp. 102–103 Polar bears, Canada**

Nursing twin cubs out in the open, a polar bear mother keeps a wary eye out for intruders. Born tiny and completely helpless, cubs grow rapidly on a diet of rich milk. They emerge from the den a few months later, in early spring.

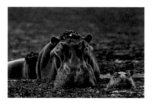

**pp. 104–105 Hippopotamus, Botswana**

Aquatic plants perched on her head, a hippopotamus wallows languidly with her calf in one of the many channels of the Okavango delta. These heavyweight vegetarians can weigh up to three tons.

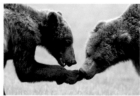

**pp. 106–107 Brown bears, Katmai, Alaska**

Brown bears have between one and three offspring, the fiercely protective female raising cubs on her own. These playful twins will stay with their mother until they are about three years old.

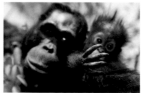

**pp.108–109 Orang-utans, Borneo**

Dependent on their mothers for at least five years, orang-utan babies gradually learn skills which enable them to survive alone. Reaching sexual maturity in their teens, these solitary red apes give birth to only four or five babies in a lifetime.

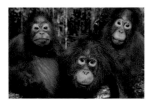

**p. 111  Orang-utans, Borneo**

Three juvenile orang-utans approach for a closer look. The only great apes in Asia, their natural habitat is under increasing threat from logging, and deforestation for agriculture and palm oil plantations.

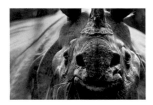

**pp. 112–113  Indian rhinoceros, India**

Short-sighted and bad-tempered, rhinos are quick to charge. Despite their enormous bulk and tank-like physique, they are highly endangered due to a demand for rhino horn in Eastern medicine, and for ceremonial dagger handles.

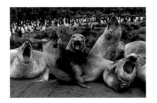

**pp. 114–115  Elephant seals, South Georgia**

A noisy group of elephant seals bellow raucously on the island of South Georgia. Coming ashore only to breed or to moult, they can fast for long periods and lose up to a third of their body weight.

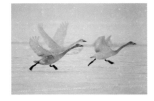

**pp. 116–117  Whooper swans, Japan**

In the harsh cold of Hokkaido, the most northerly Japanese island, geothermal activity maintains an ice-free margin along a frozen lake. Here large flocks of whooper swans from Russia overwinter.

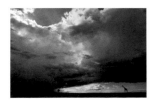

**pp. 118–119  Giraffe, Masai Mara, Kenya**

Beneath a dramatic sky, a lone giraffe walks across the African plain. The tallest living mammal on Earth, mature giraffes are formidable opponents, and can often fend off potential predators with a savage kick of the hind legs.

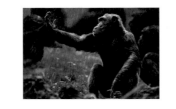

**p. 121  Chimpanzee, Monkey World, England**

A chimpanzee pensively holds out his hand to experience the warm summer rain. Our closest living relatives, chimps are highly intelligent, and display very human characteristics such as primitive tool use, self-recognition and altruism.

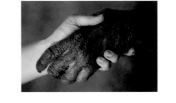

**p.128  Chimpanzee and human, England**

Reaching out across the divide between species, a chimpanzee clasps hands with her carer. Monkey World ape rescue centre rescues captive chimpanzees from human abuse, rehabilitating them into social groups.

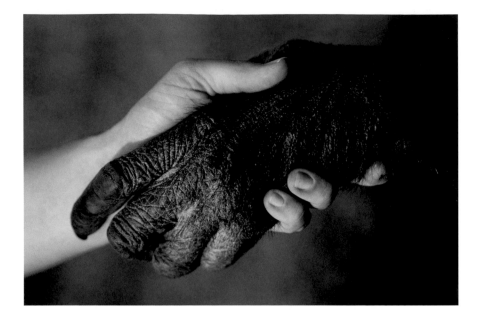

# QUOTATION ACKNOWLEDGMENTS

*We are grateful to all the authors of quotations used and in particular for permission to quote from the following works in copyright.*

p. 18 **William Ralph Inge:** from *Outspoken Essays* (Longmans Green, 1919), by permission of Christopher Inge for the family and heirs of the Very Rev. Dr William Ralph Inge.

p. 24 **Mahatma Gandhi:** epigram by permission of the Ghandian Institute, Bombay.

p. 38 **Gerald Durrell:** from *Catch me a Colubus* (Collins, 1972), by permission of The Estate of Gerald Durrell and of the Durrell Wildlife Conservation Trust which he founded, www.durrellwildlife.org

p. 52 **Christine Stevens:** founder of Animal Welfare Institute, by permission of the A.W.I.

p. 54 **Douglas Adams:** from *The Hitch-Hikers Guide to the Galaxy* (Pan, 1979), copyright © Douglas Adams 1979, by permission of the Estate of Douglas Adams, c/o Ed Victor Ltd, and of Macmillan, London, England.

p. 60 **George Orwell:** from *Animal Farm* (Secker & Warburg, 1945), copyright © George Orwell 1945, copyright © Harcourt, Inc 1946, renewed 1974 by Sonia Orwell, by permission of A. M. Heath & Co. Ltd. on behalf of Bill Hamilton as the Literary Executor of the Estate of the late Sonia Brownell Orwell and Secker & Warburg Ltd, and of Harcourt, Inc.

p. 74 **George Weiss and Bob Thiele:** from 'What a Wonderful World', words and music by George David Weiss and Bob Thiele, copyright © 1967 by Range Road Music Inc., Quartet Music Inc. and Abilene Music Inc., USA, copyright renewed; All rights reserved. Lyric by permission of Carlin Music Corp., London NW1 8BD, and Memory Lane Music, c/o International Music Network Ltd, London.

p. 76 **Oscar Hammerstein:** lines from 'You'll Never Walk Alone', words by Oscar Hammerstein II, music by Richard Rodgers, copyright © 1945 Williamson Music International USA, by permission of EMI Music Publishing Ltd., London WC2H 0QY.

p. 84 **Christiaan Barnard:** words by permission of the Executor of the Estate of Christiaan Barnard and of the Christiaan Barnard Family Trust.

p. 94 **Rose F. Kennedy:** from an interview with Cleveland Amory, 'An American Testament of Faith: Rose F. Kennedy', in *Parade*, 3.7.83.

p. 100 **Emily Dickinson:** from letter 455 to Eugenia Hall, 1876, in *The Letters of Emily Dickinson* ed. by Thomas H. Johnson (The Belknap Press of Harvard University Press), copyright © 1958, 1986 by The President and Fellows of Harvard College, 1914, 1924, 1932, 1942 by Martha Dickinson Bianchi, 1952 by Alfred Leete Hampson, 1960 by Mary L. Hampson, by permission of the publishers.

p. 106 **Albert Schweitzer:** from *The Philosophy of Civilization* trans. by C. T. Campion and J. Naish (A. & C. Black, 1929), by permission of the Association International du Dr Albert Schweitzer de Lambarene.

p. 108 **Bradley Millar:** by permission of Bradley Millar, Director, Humane Farming Association.

p. 112 **Romain Rolland:** from *Les Cahiers de Romain Rolland* (A. Michel, 1978), held at the Romain Rolland Archives, National Library of France, reprinted by permission of the Bibliothèque nationale de France (BnF).

p. 114 **Ellen Degeneres:** by permission of Ellen Degeneres c/o IDPR, California, USA.

p. 116 **Charles Lindbergh:** from 'Is Civilization Progress?', *Reader's Digest*, July 1964, by permission of the family of Charles Lindbergh and of the Lindbergh Foundation, www.lindberghfoundation.org

p. 120 **Dr Jane Goodall, DBE:** founder of the Jane Goodall Institute, UN Messenger of Peace, from *Reason for Hope: An Extraordinary Life,* with P. Berman (Thorsons, 2000), by permission of the author and the Jane Goodall Institute, www.janegoodall.org

*Where known, the following quotations out of copyright are drawn from the following sources.*

p. 11 **Charles Darwin:** *The Expression of Emotions in Man and Animals,* 1872

p. 16 **St Francis of Assisi:** St Bonaventura, *The Life of St Francis, c.* 1872

p. 20 **Chief Seattle:** Letter to President F. Pierce, 1855

p. 26 **William Blake:** *Auguries of Innocence,* 1863

p. 28 **Herman Melville:** *Moby Dick,* 1851

p. 30 **Jean Paul Richter:** undetermined source and date

p. 32 **Jacques Deval:** *Afin de vivre bel et bien*, date unknown

p. 50 **George Eliot:** *Mr Gilfil's Love Story,* 1857

p. 56 **John Donne:** *Progress of the Soul,* 1612

p. 58 **Thomas A. Edison:** *Harper's Magazine,* 1890

p. 66 **Charles Darwin:** *Metaphysics, Materialism and the Evolution of Mind,* 1859

p. 68 **Arthur Schopenhauer:** *Über die Grundlage der Moral,* 1840

p. 70 **Maimonides:** *Guide to the Perplexed, c.* 1190

p. 86 **Mark Twain:** *What is Man?,* 1906

p. 92 **Aesop:** *The Jay and the Peacock, c.* AD 300

p. 96 **Robert Browning:** *The Ring and the Book,* 1868–69

p. 102 **Voltaire:** *Traité sur la Tolérance,* 1763

p. 104 **Plato:** *Timaeus, c.* 360 BC

p. 110 **Robert Browning:** *Saul,* 1854

*Every effort has been made to trace the copyright holders of the quotations contained in this book, and we apologize in advance for any unintentional omissions. We would be pleased to insert the appropriate acknowledgment in any subsequent edition of this publication.*